CHILD PHOTOGRAPHY
SIMPLIFIED

A MODERN PHOTOGUIDE

CHILD PHOTOGRAPHY SIMPLIFIED

by

Suzanne Szasz

AMPHOTO
Garden City, New York 11530

To my husband, Ray Shorr,
who edited the kinks out of this book—
and my profuse thanks out of this dedication . . .

Copyright © 1976 by The American Photographic Book Publishing Co., Inc.
Published in Garden City, New York, by American Photographic Book
 Publishing Co., Inc.
All rights reserved.
No part of this book may be reproduced in any form without the written
 permission of the publisher.
Manufactured in the United States of America.
Library of Congress Catalog Number—75-27833
ISBN—0-8174-0190-3

CONTENTS

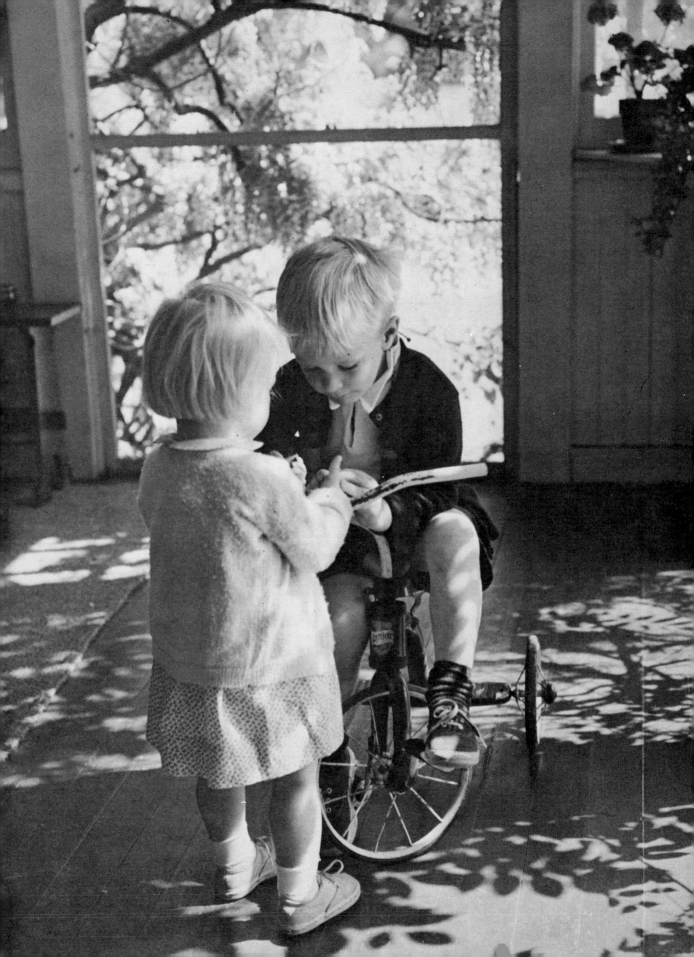

FOREWORD

Over three billion pictures were taken in the United States in the past year. According to conservative estimates, about 60 per cent of these were taken of children.

I often wonder how many of this staggering total were wasted by faulty exposure, bad focusing, or bad timing? How many children were filled with a dislike for having their picture taken? How many opportunities for wonderful photographs were lost.

Although more and more cameras are sold every year, one sees no improvement in picture quality. Amateurs still blast millions of flashes directly into their subjects' faces each year and still send their films to mass processors without knowing how they will be developed.

Professionals, on the other hand, have known how to shoot by available or bounce light for years. Many a professional photographer will tell you how often children express their astonishment upon discovering how easily and painlessly he or she can take their picture.

How many pictures of children, taken by their parents, would interest a stranger? One can usually spot the children who have grown to hate having their parents photograph them, by the glassy smiles they present to the camera, no matter how they feel. The question is why?

Why are so many people obsessed with their photographic equipment but rarely interested in their subjects?

I can't answer these questions. All I can do is to tell you what I have learned in the more than twenty years that I have been a photographer.

Above all, you must approach the child you wish to photograph with love and respect and the intent to show him as he really is—how he laughs, how he cries, how he dreams, how he grows, when he's sad, when he's bursting with love, what he wants, and so forth.

Do we see these features in the child with shiny slicked-down hair, who is writhing in a freshly starched shirt and being cajoled to grimace in front of an ugly little black box we call a camera? I don't think so. (Half an hour ago, that child had a date with a sandlot, four buddies, and a ball and bat.) We cannot possibly expect good, true, and esthetically satisfying pictures from such inconsiderate and autocratic tactics. A good sitting will come about spontaneously. This means that as a parent, you should keep your camera ready to shoot all the time.

And if you are a photographer who has come to a child's home to take his picture, you must be prepared to spend some time getting to know him and talking to him; then take your cue from him. Fine photographers, like Arnold Newman or Jill Kre-

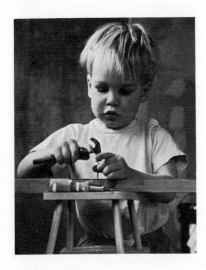

Gerry was so absorbed in his carpentry that he didn't realize I was taking pictures of him. After a while, he came up to me and asked, "Well, don't you want to take pictures of me?"

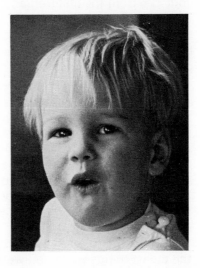

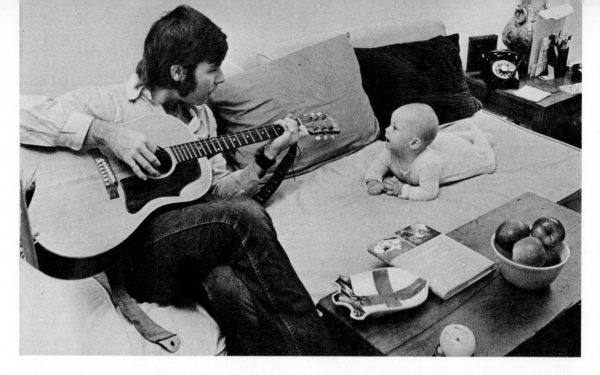

mentz, who produce wonderful pictures of people "in their natural habitat" often say that they really don't know what kind of pictures they will take until they have had a long chat to get acquainted with their subjects. Don't children, too, deserve this same care and deference to their personalities?

News about a bases-loaded home run will elicit poor response from a boy absorbed in collecting butterflies. And if a little girl is much more interested in bicycles than dolls, forget about using a doll in the pictures to bring out her warmest responses; she may just sit there and scowl. By taking your cue from the children and not forcing them to follow your demands, more often than not they will willingly humor you *later* by posing for pictures with a baseball glove or doll, if you still want them to do so.

Remember that children love to playact and that they are wonderful at it. When you play with them on their own level—listening intently as Mary talks to her daddy via a ten-cent toy telephone or watching closely as Johnny, dressed in his space helmet, glances apprehensively over your shoulder at approaching Martians—you have entered the child's world, and your photographs will show it.

And when you learn that your child did the cutest things while you were away, this playacting approach will help you recapture and recreate those moments.

When I am called to photograph a child, I always ask the parents not to talk about the impending photographic session as something special; I want the child to keep right on doing whatever he or she is engaged in on that particular day. This often results in a funny situation: After I have taken dozens of pictures of a child at play he will come up to me and say, "Take my picture!" I oblige, of course.

Whenever I encourage people to master the handling of their equipment so well that they can practically forget about it, they say, "But that's impossible! How *can* you take meter readings, set shutter speeds and *f*/stops, and adjust lights without thinking about it?" In reply, I like to quote Cartier-Bresson, who compared the experienced photographer's routine to that of a good typist. Neither has to think consciously of every detail, every letter, he said, yet they still perform almost flawlessly.

Freed from worry, you can devote yourself to the more important aspects of photography and make it all seem easy and pleasant. There is no nicer reward for a photographer than hearing a child say goodbye and asking, "When do we take pictures again? That was fun!"

EQUIPMENT AND TECHNIQUES

I hope you are not interested in technique for its own sake and that you are not going to use your child or your neighbor's child to test one camera and film after another, endlessly. It is true that camera manufacturers and chemical engineers are trying to find better and better tools for photographers and that we should try to learn about them to see which ones will make our work easier and better. But if we do no more than experiment, if we get obsessed with technical details, we may get into the habit of seeing no more than technique in our own and other people's pictures. Our experiments should, I think, extend to other fields than fine grain versus coarse grain, the respective merits of different filters, and the like.

If you are one of those people who, when shown a photograph, immediately ask, "What exposure did you use?" or "How did you get such fine grain?" I urge you to realize that these are lesser things in a picture. If it were a photograph of mine that you were looking at, I would expect you to comment primarily on whether you found beauty, excitement, or information in it and only to inquire secondarily about the technical details. I would much rather tell you about the person in the photograph and any interesting circumstances I remembered about the picture-taking than about exposures and developers. In my opinion, the technical details are not as important as the emotional, personal data.

Before I finish this exhortation, let me tell you a joke that sums it all up. A painter visited a photographer who proudly showed him his latest work. "Wonderful!" exclaimed the painter. "What camera did you use?" And again, "Beautiful! You must have some wonderful lenses." Soon it was the photographer's turn to visit the painter. Looking at his latest canvases, he said, "Gorgeous! Tell me, where *do* you buy your brushes?"

The following pages of information on tools and simple techniques are given in the hope that you will master this knowledge thoroughly, stick with a camera you like and a couple of developers that you have come to know, and thus armed, concentrate on taking good photographs.

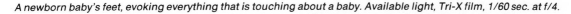

A newborn baby's feet, evoking everything that is touching about a baby. Available light, Tri-X film, 1/60 sec. at f/4.

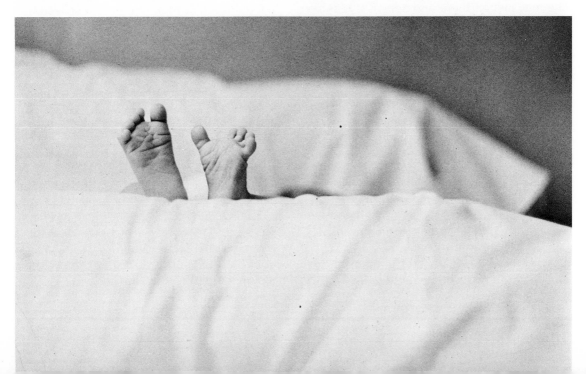

CAMERAS

Even after having used a camera for years, day in and day out, I can hardly believe that a little metal box with a piece of glass at its front can render everything we see so accurately. But then, I have never stopped thinking of the simplest radio as anything but a miracle.

There are two extreme groups of people when it comes to cameras. The first group doesn't care much what it photographs, as long as it can be done with the newest camera, lens, or gadget; these people's pictures usually *sound* better than they *look*. The second group recoils in horror if a camera has more than two small knobs on it; I think these people deprive themselves of much pleasure that better equipment would bring them.

I would encourage you technique fans to pay a little more attention to the results you get and to the purposes for which you can use your photographs. And to the haters of knobs and numbers, let me put it this way: If you are able to understand the workings of a modern oven, you'll understand cameras. Time and temperature are the two variables that control the oven. For instance, if you want to bake a cake for one hour at 350 degrees, it stands to reason that if you want to cut the time, you have to increase the temperature. In photography, *f*/stop (lens aperture) and shutter speed are the two controls that affect exposure. If you want to photograph fast action (cut down the exposure time), you have to increase your shutter speed and open up your lens aperture to a wider *f*/stop (the larger the aperture, the smaller the *f*/number).

With cameras, as with most things in life, you have to pay for every advantage. Single-lens reflex cameras (SLR's), like the Nikon, Minolta SR-T's or Minolta XK, and the Nikkormat EL, are the most pleasant to use. You see everything as it will appear in the

Teacher sympathizes with boy who is hurt. Available light in schoolroom, Minolta with 85mm lens, Tri-X film, 1/125 sec. at f/4.

"Peek-a-boo!" Available light, Tri-X film, 1/125 sec. at f/4.

finished print or slide. However, the SLR's are heavier and noisier than rangefinder cameras. The latter are silent and feather-weight, but present you with the problem of parallax. Instamatic cameras, on the other hand, are light and easy to use. Basically, however, you have to adapt the circumstances to these cameras, not the other way around, as such cameras are not very flexible. The larger format cameras, like the Mamiya RB67 or the Pentax 6 x 7, both 2¼" roll film cameras, are now staging a comeback. The picture quality you get with these cameras is beautiful, if you are willing to put up with more weight and more expensive film.

More and more cameras are now either fully or semi-automatic; once you set your film speed, the camera does the rest. Contradictory as it sounds, I would only recommend such cameras to photographers who already have some experience and want to pamper themselves. A beginner would blame all mistakes on the camera and never learn the basic steps and concepts that are essential for improving as a photographer.

One great luxury is a camera with interchangeable lenses. Fixed-lens cameras come with so-called normal lenses, but cameras with lens interchangeability can accommodate normal as well as telephoto, wide-angle, zoom, and other lenses. Telephoto lenses of 85–135mm will permit you to "fill the frame" of a 35mm negative with the subject's head, without distortion, from five or six feet away. From the same distance, a normal lens of 45–55mm will give you the upper body of your subject as well; a wide-angle lens of 35mm or less will incorporate the full figure. Telephoto lenses have a shallow depth of field, so you have to focus carefully. Wide-angle lenses have a greater depth of field, so your subject as well as your background will be sharp.

My advice on cameras is this: Get to know your camera, and don't practice on your child right away. Nature is much more patient, so photograph flowers or stones. Save photographing your child for the time when photography becomes easier for you, when you don't have to think about the mechanical aspects so much of the time. Also, read the brochures that come with your camera; they are mostly very informative.

(Opposite) Daylight, Tri-X film, 1/125 sec. at f/2.8. Note distortion caused by going in close with a 50mm Macro Rokkor lens. (Above) Children's play is their work. Available light from windows and dining-table light, Tri-X film, 1/60 sec. at f/4.

ACCESSORIES

No matter which camera you own, there are a few (and I do mean *few*) accessories that you ought to have. A *sunshade (lens hood)* is one. I never photograph without one, indoors or outdoors, with or against the light. Rubber sunshades, which collapse when not in use, are now available; they are wonderful.

Frankly, I don't often use *filters,* but if you are interested in them, a K2 filter for clouds outdoors and a Skylight (1A) filter for warming up certain color situations will be adequate. We shall discuss their use later.

I would urge you to keep a *lens cap* on your camera when you are not using it. If you own a 35mm camera with interchangeable lenses, be sure you have a lens cap for each of them. This may sound too obvious to mention, but when you complain about faulty definition in your pictures, you should realize that it may be due to improperly cared-for lenses.

To clean a lens, first blow off any surface grit or dust with a small *ear syringe* (your drugstore has them). Then brush off any persistent dust with a soft *lens brush;* there's one that looks like a lipstick and fits easily into the smallest camera case. Now wipe the lens gently with good *lens tissue.*

A word about *camera bags.* Try (and this won't be easy) to get one in which you can arrange your equipment properly for use. I have seen beautiful big camera bags into which three or four cameras, plus extra lenses, filters, film, light meters, and other paraphernalia had been thrown so carelessly that it must have taken at least 15 minutes to get anything ready for shooting. The opposite of this mess is the small, minutely and expertly compartmentalized bag, which has to be packed so exactly that it is impossible to replace a camera once the lens cap has been removed and the sunshade put on. Such an arrangement does not serve our purposes either, which is, to be ready to shoot fast and to protect our equipment.

I would encourage you to get rid of your leather carrying case and to keep your camera in a soft bag, always at the ready. Most cameras come without straps; be sure to get a strap that attaches to the camera body. It shouldn't be too long and should just clear your head comfortably.

EXPOSURE METER

More and more cameras come with built-in light meters, and there is no denying that they are convenient. However, they add to the weight and price of the camera. So if you want to keep using your old camera or economize when getting a new one, a separate exposure meter is still a perfectly workable saving, one which won't affect the quality of your pictures in the least. Most older camera models without built-in light meters cost much less and are, in most other respects, just as good as the newest models.

There is no better way to understand the mechanics of picture-taking than by playing around with a light meter, even before starting. The first thing you will learn is that knowing your film speed and setting it on the light meter is the first indispensable step. After all, films vary greatly in their speed, so there should be no guessing around; for example, Kodachrome 25 is ASA 25, but Kodak Tri-X Pan is ASA 400—a 16-fold difference!

You will also learn that with a certain light meter reading, a whole series of settings is correct, and you will start thinking about which ones to choose for your particular wishes. Do you want to stop action with a fast shutter speed? If so, your f/stop will have to be correspondingly in the low numbers, i.e., fairly wide open. Or do you want to stop down to f/11 in order to show several people and the background sharply? If so, your shutter speed will have to be increased.

Only experience will teach you how to avoid situations in which your meter (and you) are fooled by an extremely light or dark background. When this happens, you end up with under- or overexposure in the most important part of the picture: on the face of the child you are photographing. Taking a close-up meter reading is helpful, but that is not always possible. Adjusting your exposure by one stop more or less than what is indicated on your light meter will usually ensure against bad mistakes.

In both of these photographs, it was necessary to correct the meter readings. Sarah's face needed more exposure than the white sheets, which fooled the light meter. On the other hand, Hazel's face needed less exposure than the dark background caused the light meter to record. I am always aware of what it is I am really trying to render faithfully and what part of the picture can be allowed to be over- or underexposed. The correction usually consists of one f/stop.

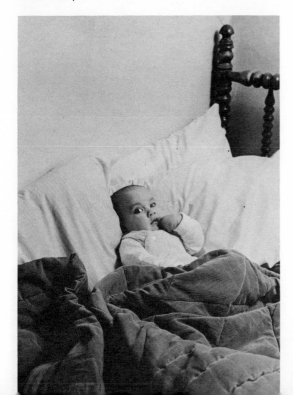

FILMS

I could go through a long list of films and say something nice about each one, but I would rather urge you to stick with one film for each purpose. I use the following:

Black-and-White

Outdoors, daylight: Ilford FP4, Kodak Pana-tomic-X, or Kodak Plus-X Pan, depending on the light.
Indoors, with available light: Kodak Tri-X Pan.
Indoors, with supplementary light: Kodak Plus-X Pan or Kodak Tri-X Pan.

Color

For daylight and/or with electronic flash: Kodachrome 25, ASA 25.
For added emulsion speed: Kodachrome 64, ASA 64 and Kodak Ektachrome-X, ASA 64.

Kodak High Speed Ektachrome, daylight type, ASA 160, is especially useful for shooting indoor daylight situations where your lighting comes from windows. It also works well in daylight combined with over-head fluorescent lamps (classrooms, for instance). If need be, professional color labs can push this film to ASA 400 or higher.

For purely indoor situations without daylight, Kodak High Speed Ektachrome Tungsten is my favorite film. At ASA 125 and using two direct No. 2 photofloods or bouncing three or four of them, I have found that exposures are around a comfortable 1/60 sec. at $f/4$ or $f/5.6$, and the quality is very nice. Most of these color films come in all sizes.

Hazy day in the park. Plus-X film, 1/250 sec. at f/4.

DEVELOPING

Even if you don't do your own developing, you should know enough about it to tell the photofinisher what you want him to do. It is hard to improve your photography if you have to rely on an unknown person in a mass-production plant to develop your films by some standard formula. If there is is no reliable, professional photofinisher in your locality as yet, enough interest and repeated inquiries may result in the establishment of such a service through your local camera store.

I like to do my own developing, and I agree with most professionals that development by inspection gives the best results. I always mark my exposed rolls as to subject matter; this way I know whether a certain roll has mostly light or dark backgrounds, whether it needs pushing, and so forth.

Developers

Kodak Microdol-X or D-76 (half diluted with water) with Kodak Plus-X Pan and Ilford FP4 film. A word about D-76: If you dilute it, you cannot save and replenish it; you must discard it after use.

Agfa Rodinal or Ethol TEC compensating developers with fine grain film like Kodak Panatomic-X.

D-76 or Acufine with all films for higher emulsion speeds.

As you can see from the captions in this book, I routinely "push" Kodak Tri-X Pan to ASA 800 or higher and Kodak Plus-X Pan to ASA 200. All I have to do is develop one or two minutes longer than the normal developing time.

Two sisters caught while watching TV. Extremely low light from one window, Minolta SR-T 102 with 85mm lens, Tri-X film rated at ASA 1000, 1/30 sec. at f/2.

LIGHTS

If you wish to photograph children with great flexibility and little expense or fuss, two reflector photofloods with clamp-on sockets will prove to be your most valuable equipment. I often use one flood on the same light stand with my electronic flash, partly as modeling light and partly to supply enough light for focusing. The second photoflood can be clamped on a door, window, floor lamp, or even hung from a protruding ledge or shelf.

A hot, exploding photoflood is a real source of danger, so prepare and handle your lights most carefully! In general, you will want to use No. 2 photofloods; No. 1 bulbs are preferable when shooting a scene that includes a desk lamp or bridge lamp. Replacing the regular bulbs with them will give a completely realistic effect while providing a good light source.

If you learn to handle them safely and effectively, photofloods can give you econo-

Two windows light the background and one No. 2 reflector photoflood next to the camera lights the foreground. Minolta with 35mm Rokkor lens, Tri-X film, 1/60 sec. at f/5.6.

my, convenience, and the chance to shoot as candidly as with available light alone.

I have two lightweight light stands but often use only one with photofloods. Light stands come in different sizes and weights. The lightest 8-foot stand is my favorite. If you use a stand, avoid clamp sockets if possible. Screw-on sockets will be much more sturdy and will withstand a child bumping into the stand where a clamp would not.

I am one of those people whose wires always end up in one tangled mess, however neatly I start out. So I have come to appreciate having different-colored wires for each lamp, synch cord, and the like. This also helps me when I want to find a particular one in a hurry.

Two bounced photofloods illuminate Suzy as she tries on her father's ski jacket. Tri-X film, 1/60 sec. at f/4.

FLASH

There are many different kinds and makes of flashcubes, bulbs, and electronic flash units. Most of the simplest cameras can be used with one or the other of these, but you *must* know what shutter speeds your own camera requires. Happily, more and more cameras allow a range of 1/30 sec. to 1/125 sec.

For direct illumination with cubes or bulbs, it is easy to figure the *f*/stop necessary for your film and the subject-to-flash distance; all you have to do is measure the distance in feet from subject to flash, then divide this distance into the guide number given on the package. With nonautomatic electronic flash, the procedure is the same.

Automatic electronic flash units do all the calculating for you. A small photocell senses the light reflected from the subject; when it has received a predetermined amount of light, the photocell shuts off power to the flashtube, thereby ending the exposure. I have just acquired a Minolta Auto Electroflash 450 unit, and it is one innovation I am crazy about.

Experience will teach you how much more you need to expose if you want to bounce your flash; it depends on the height and color of walls, ceiling, and the like. You will find the result so much more realistic and pleasing that you won't want to go back to direct flash.

Bounced electronic flash, Tri-X film rated at ASA 800, f/8.

MISCELLANEOUS HINTS

I have not forgotten to mention a tripod—I just don't recommend one for child photography. Children usually move so fast that one cannot count on longer exposures than 1/60 sec. or 1/30 sec. on rare occasions. You can hold a camera steady for 1/30 sec., if you learn to control your breathing somewhat and are careful not to sway while releasing the shutter.

Carrying a large quantity of film presents certain problems—it is bulky and difficult to store. I recommend the skier's belt for the few rolls you want handy as well as for note-taking equipment. But if you are on an extended shooting trip, an insulated food bag will keep the bulk of your film from overheating or freezing, if it is not opened too often.

For my general equipment, I carry a large, loosely-packed camera bag and several pieces of blister wrapping or good-quality (non-crumbly) thin foam rubber. I usually wrap the blister or foam around my cameras and throw them back in the open bag. Nothing has ever been damaged by this rough treatment. A word of caution: Keep children away from your blister plastic; they *love* to pop the bubbles.

AVAILABLE LIGHT

I wonder what associations the words "available light" have for you. Do you immediately think of photographs taken in subways, saloons, or cellars? Most people I asked thought of dark, grainy shots taken in very poor light and "pushed" in developing as far as the film would go. Literally, available light is any kind of light in which you can photograph with no more equipment than the camera in your hand. Yes, even sunshine is available light, and so is a brightly lit stage where your child may be performing in the annual school play. So follow me on a guided tour of a child's world.

The first picture I ever sold (to Popular Photography). *Strong backlight filled in by sunlit concrete, Ilford FP4 film rated at ASA 100, 1/125 sec. at f/5.6.*

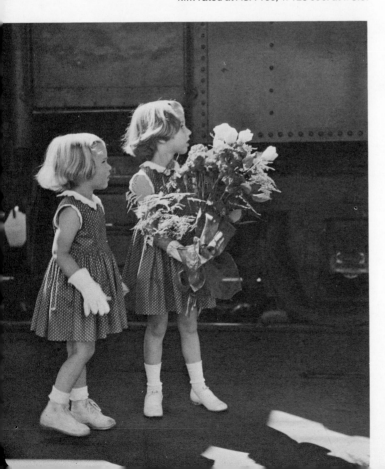

OUTDOORS IN BRIGHT SUNSHINE

Let's assume that you are past the period when you thought the sun had to be behind your back, shining into the face of your subject. Seeing all those distorted faces, squinting eyes, and harsh shadows must have cured you of this approach very fast. So whenever we talk of photographing in bright sunshine in this chapter, we shall assume that the sun is either behind or to the right or left of your subject. And we shall also assume that you never let the sun shine directly into your lens, even if you have the indispensable sunshade on it.

Whenever possible, I try to stay in the shade of a tree, beach umbrella, or some projective awning near the sunlit area where the subject is located. When this is not feasible, I tilt the camera slightly downward to keep direct sun rays from striking the lens.

When I started photographing, someone made me a beautiful silverfoil reflector. I shall never forget how delighted I was with the perfect fill-in it produced. But I soon found that not only was it painful to the eyes of the children I photographed, it also drew much too much attention to my presence and took lots of time to handle. I can't imagine using one today; except for fashion photography, it is not only a superfluous but a disturbing piece of equipment as well.

You must be more subtle than that. If you can pick your shooting location, bear in mind that cement, gravel, and stone surfaces are also reflectors—nearly as good as sand and water. Of course, the reflecting surface should be directly lit by the sun. For example, the lighting for the photograph of the two children at the train was ideal. Note that the two children were directly on the borderline of sunshine, with enough well-lit asphalt between them and the camera to provide a good fill-in.

But suppose you must use non-reflecting surfaces, like lawn or meadow, and no dark background is available. In this case, you can choose one of two methods to maintain shadow detail: (1) expose for the shadows and let the background get overexposed; or (2) provide a simple reflector that does not distract the subject and is easy to handle. A white towel, for example, will do wonders. I usually spread it on my knee or on the ground. Sometimes, wearing white or light-colored clothing will help, but carrying a towel is a simple and sure aid for backlit pictures on the lawn. With sidelighting, you may occasionally need some fill-in too.

There is, of course, a simple solution to all these fill-in problems. No, *not* flash or strobe; just don't shoot on bright sunny days! This advice is offered half in fun. Don't we all remember the time when photographers prayed for good, sunny weather? No more!

Two friends photographed at the children's concert of the Fox Hollow folk festival. Plus-X film rated at ASA 200, 1/125 sec. at f/4.

OUTDOORS WITHOUT SUNSHINE

On bright overcast days, the light will be soft and strong without harsh shadows. With children as spontaneous and impulsive as they are, you will appreciate the ease with which you can shoot from any direction on a hazy day or in the open shade, where the subject is lit by unimpeded light from the sky.

On such days, you can shoot as long as you can see to focus, and if you have to use wide-open f/stops, they blur the background pleasantly. But remember, while in contrasty sunny lighting you should reduce contrast by slight overexposure and proportionate underdevelopment, on overcast days you should increase contrast by slight underexposure and proportionate overdevelopment. In addition, the use of high-speed films and strong developers, such as those discussed on pages 16 and 17, greatly extend the photographer's working day, despite the lack of sunshine.

My favorite light, lens, and f/stop for photographing children: open shade, 100mm Rokkor, and f/2.8; Plus-X film and 1/500 sec. shutter speed.

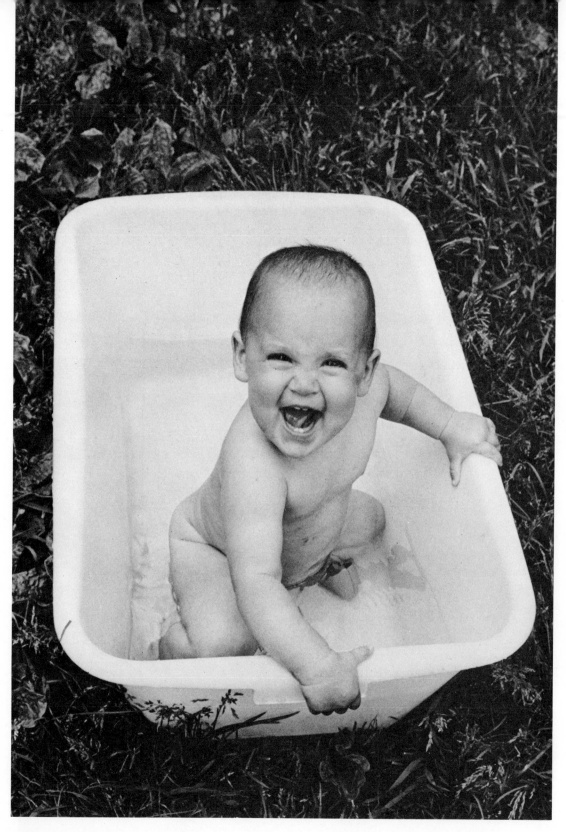

Sarah enjoys a bath in the shade during summer heat. In this case, high camera angle creates good design.

Sports

When photographing your child during his favorite sports activity, again avoid strong sunshine if possible and try to get in close to your subject. For sharp pictures, shoot at fast shutter speeds—at least 1/125 sec. at the peak of the action. On the other hand, a blurred arm or bat will increase the sense of speed and movement and may provide you with more effective pictures.

By varying your camera angle, sight your subject against the least confusing background so that he will stand out. If you want to experiment with panning, sports photography offers many opportunities. Panning is simple enough: Swing your camera smoothly and evenly to keep the moving subject in your viewfinder, make the exposure, and "follow through." Whether you are successful or not, one thing is certain: It will *not* be a dull roll.

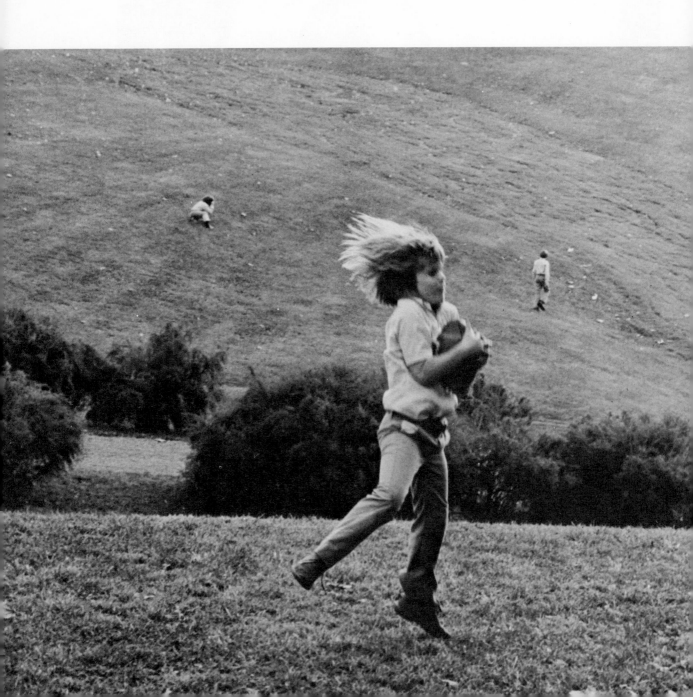

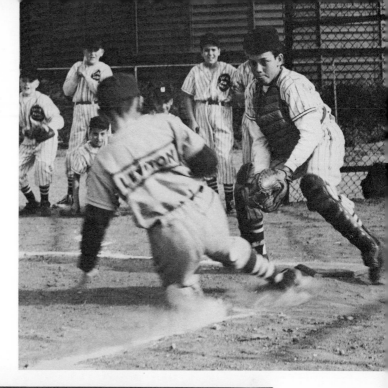

All three sports photographers benefit from even, diffused light, fast shutter speeds, and simple backgrounds that emphasize the action.

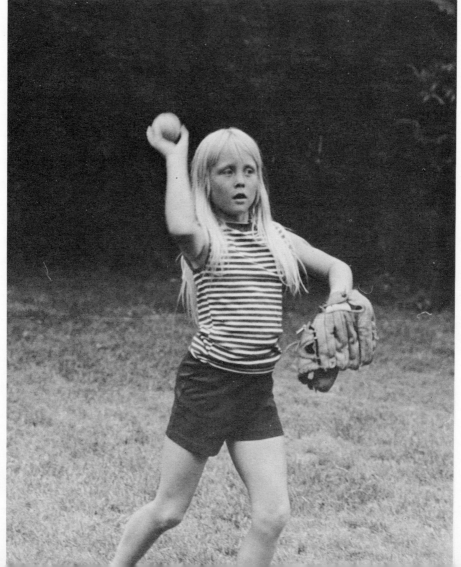

Camp

Photographing children at camp does not call for any special instructions here (more about this later). The important thing is that you should try to enter into the spirit of the place and capture the zest and newness of the surroundings as the child experiences them. *Identification* and *empathy* may be fancy words, but the feeling is simple enough. No conscious effort is needed to put yourself in the child's place.

Camp does peculiar things to children: The shy little girl may turn out to be the ringleader in the roughest games, while the devil-may-care attitude of a tough little boy can change into tender solicitude when his best friend happens to need protection or help.

So don't be surprised if parents hardly recognize their children in your candid camp shots. You can be proud to show these new aspects of their children to parents and to suggest that if they don't recognize them, they might do well to treasure your pictures as proof that parents can keep learning about their children all the time.

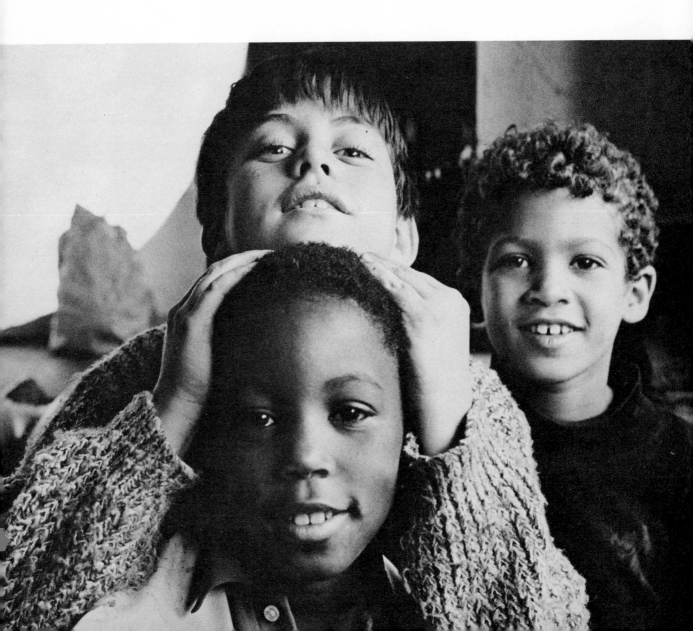

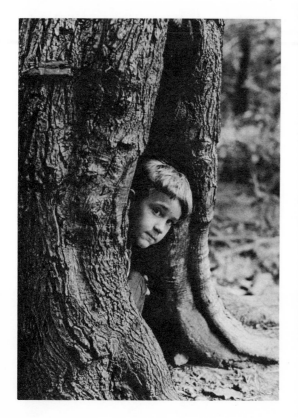

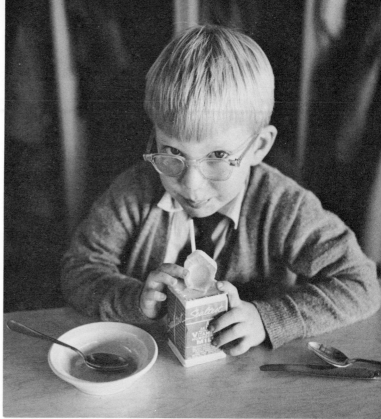

Camp life. Three photographs were taken by available light: the first, indoors, close to a window; the second, outdoors in the shade; and the third, in the dining room. The fourth was filled in by (yes!) a direct photo-flood; Olivia was painting in the doorway.

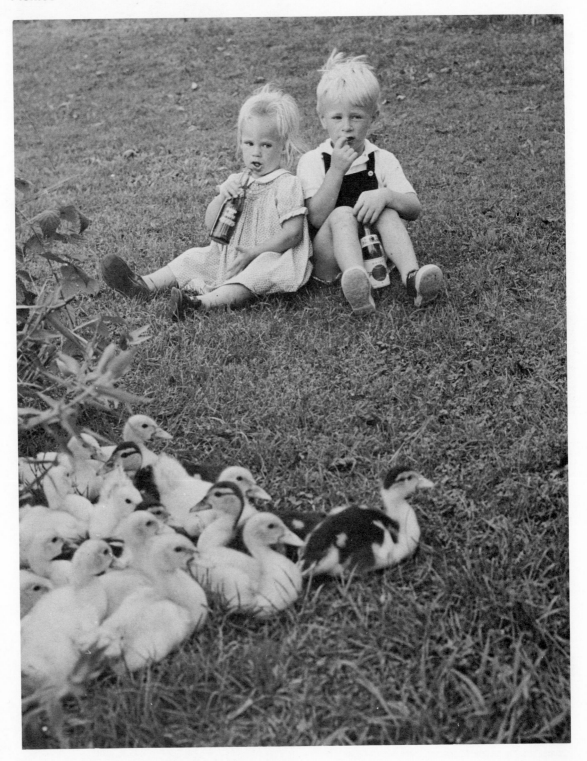

The ducks are cute, but Howard and Chrissy keep a respectful distance. Overcast day, Ilford FP4 film, 1/125 sec. at f/4.

A family outing may involve many different lighting and exposure situations: pictures of someone preparing the sandwiches in the kitchen; the children at a sunny brook; or lunch under a shady tree. There are three ways to keep the film balanced and uniform so that development will be no problem.

1. Set your meter at an ASA rating sufficient for the most poorly lit situations yet not so high as to require impossible shutter speeds in the brighter situations. Suppose you start a roll, rated at ASA 400, for shooting the preparation of the sandwiches in your kitchen; the exposure may be 1/60 sec. at f/4. You may find later that continuing the same roll at ASA 400 will require settings like 1/1000 sec. at f/22 at the sunny brook—an unnecessarily extended range. Obviously, you must shoot at home at no more than ASA 160, if you want to combine the roll with later outdoor shots. That means, 1/30 sec. at f/2.8 in the kitchen.

2. Better yet, remember that film is relatively cheap; don't ruin three or four valuable indoor shots on a roll by combining them with brightly lit outdoor shots that require different processing. Empty your camera and reload for the outdoor shots.

3. If you happen to own two cameras, load both with black-and-white film for occasions like a picnic. Use one camera indoors and in shady situations outdoors; set the other at an ASA rating good for sunlit situations. Be sure to mark your cameras so you know which is which. A small piece of paper reading "ASA 400," for instance, can be taped to the camera in a visible spot and removed later.

If yours is a 35mm camera, it is very good practice to have a few 20-exposure rolls handy for such occasions. You can save money by loading bulk film in any length into cartridges.

The whole family is investigating the tiny fish around the dock. Hazy sunlight, Plus-X film, 1/125 sec. at f/8.

AVAILABLE LIGHT INDOORS

Suppose the sun is shining brightly through the window when you decide to take pictures of a child indoors. Just as in outdoor photography, don't let the sun shine directly on your subject's face. And don't be tempted by this strong light even for backlit shots, unless you are willing and able to provide a powerful reflecting surface. A polished light-colored floor or a very light carpet will fill in sufficiently if the sun hits them directly in front of the subject.

In my picture of Paul, I used the bedspread as fill-in and was careful to place the child so that his face was never directly lit. (When I say that I *placed* the child, I only mean that I changed my own vantage point. I moved around until I was sure I had gotten rid of all direct sun rays on his face.)

It was while taking backlit pictures in a hospital that I made a small discovery: Every time a nurse passed, the children's faces were lit up. Soon I realized that the nurses were acting as mobile reflectors and

that by donning one of their white uniforms I could be one too. Since that time, whenever it does not attract too much attention, I put on a white coat, which I carry with me for this purpose.

So if you like backlit pictures indoors, you would do well to wear a white coat or light-colored clothing or to use the towel-sheet technique I described for outdoor use as fill-ins. You can also combine available light with a floodlight or electronic flash for fill-in; we talk about this in later chapters.

Using available light indoors will usually mean that you turn your back to the window while your subject faces it without, however, being in direct sunlight. Rooms with windows on more than one side are ideal because the illumination becomes more general. Unless the day is exceptionally dark, the light should be sufficient. I find that by using Kodak Tri-X Pan and setting my light meter at ASA 1000 I can usually shoot around 1/60 sec. at f/4 to f/8.

(Left) This picture includes an otherwise superfluous background to illustrate the technique of using sunlight reflected by a white bedspread as fill-in. Tri-X film, 1/125 sec. at f/5.6. (Opposite) Using available light and a wide-angle lens allows us to show more than a country mother and her baby; we also get a glimpse of their home and their way of life. Minolta with 35mm Rokkor lens, Tri-X film, 1/60 sec. at f/5.6.

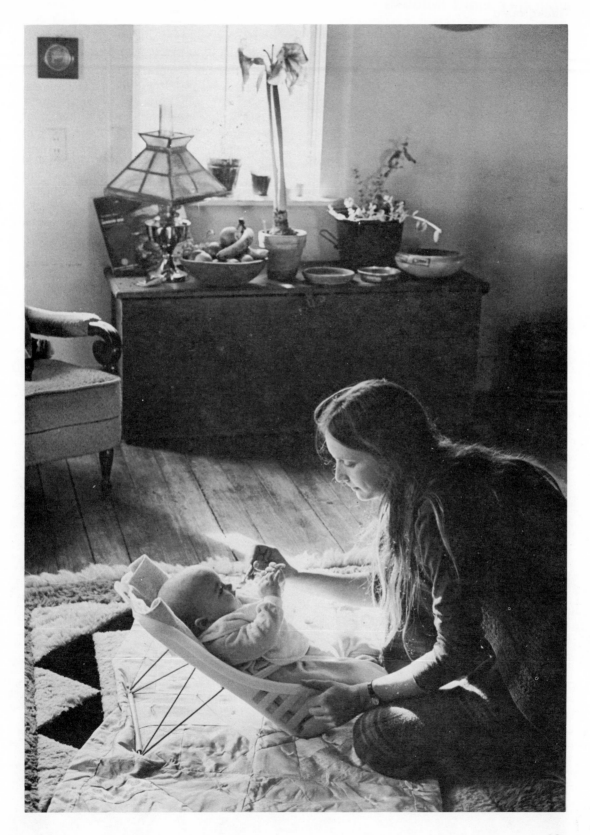

Background

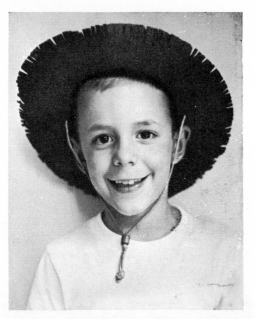

There is another advantage to using only available light in a room: You will not have the problem of your subject "sticking" to the background. If you have tried floods or flash, you will know how many times a child's pink face and a blue dress will be rendered in the same tone of gray as a partially lit white wall. By keeping your subject far enough from the walls, you will find that even white walls will appear dark gray or even black in your photographs.

In the first picture you see here, Bruce was leaning against a white wall near a window; the fact that he was wearing a dark cowboy hat was the only thing that saved the picture from being the same tone of gray throughout. In the second photograph, Sonya was about ten feet from the wall; I prefer the second shot because there

is better tonal separation between her face and the wall.

I am not the person to encourage you to make many tests, but I do wish you would photograph a child against a white wall. Assuming that the light on the subject stays the same, move him away from the wall, two feet at a time; you should see marked changes in the tone of the wall when you print your pictures.

I know you cannot redecorate every apartment or home in which you take pictures, but if you try, you can usually find a plain background. However, if such does not exist, remember that colors and tones change enormously, depending on how close or far from them the light is located.

Conscious observation of the background, especially in terms of distance and color, will give you better pictures. One of the reasons why most beginners take better color pictures than black-and-whites lies in the fact that in color photography, there is no need to "translate" blue or pink into different shades of gray as you must try to do in black-and-white photography. With color film, a brown dog lying on green grass will always be visible—something that does not hold true for black-and-white.

You can also control your background by varying your lens opening. We know, of course, that the more we stop down the lens, the greater will be our depth of field. Reverse this and we find that by opening our lens, we shall not have to worry as much about backgrounds as we would if we were using f/8 or f/11. Furthermore, our subject will now stand out beautifully against a background that is not seen sharply but is *felt*, just by letting it go soft and blurry.

Working with such wide openings for out-of-focus backgrounds, you must remember that exact focusing is vital. "Exact focusing" means that the most important

This photograph illustrates the selective use of a wide-open 100mm lens. The shallow depth of field blots out background, including other children.

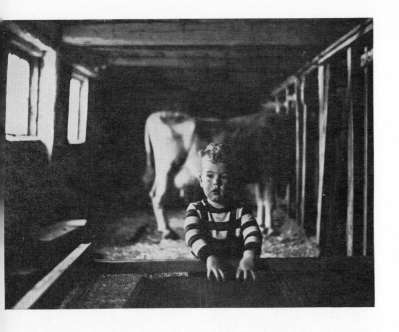

point in the picture will also be the sharpest: in the case of one child, that point should be his eyes; in the case of a group, it should be the most important child.

By studying some depth-of-field charts, either on your camera or in an instruction book, you will soon learn how much will be in focus with the relatively large lens openings available light photography demands. Except in a situation involving many equally important subjects, where a fast wide-angle lens or the use of additional light sources, like floods or electronic flash, would be the best solution, the shallow depth of field can be turned into an advantage because it puts the emphasis of a picture where it belongs —on your specific subject.

So much for the technical points of using available light. You must admit they are simple: Use a light meter; always remember to expose a roll of film at the same ASA setting; watch your backgrounds; practice accurate focusing; and do all this often enough to make it practically automatic. When you have mastered these simple points, you will be ready to concentrate on the important aspects of photography. I still get a thrill whenever I can set out to shoot pictures, armed only with my camera with a built-in light meter and some film.

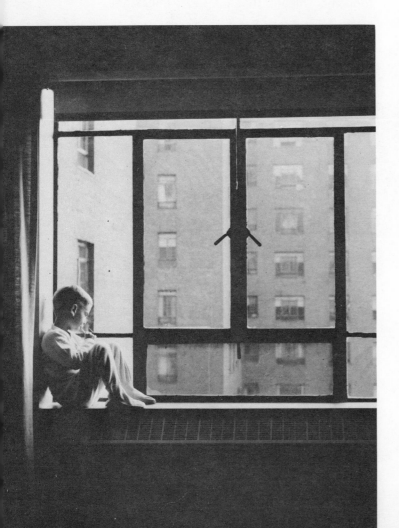

Backgrounds can be used constructively to provide information about your subjects. Here a country child is contrasted with a city child. Available light, Tri-X film, 1/60 sec. at f/4.

Available light photography, with fast films and strong developers, makes picture-taking at school simple and pleasant. Once the teacher understands that you won't bring in any distracting equipment or interfere with class routine, he or she will usually consent to your taking pictures.

It is advisable to get permission from the principal ahead of time. You would be wise to show him some of your photographs taken under similar available-light conditions. Even these days, few people know that normal room light is sufficient for picture-taking; to prove it, one picture will be worth ten thousand words.

Once in the nursery or classroom, it is up to you to overcome the natural curiosity of the children. Your greatest weapon is pa-

tience; their interest in the stranger and his fascinating black box will subside after a while. Don't expect miracles in the first hour or so, but also don't forget that an extremely shy child or a constantly mugging one, both aware of you, still makes for excellent pictures.

I usually sit down in an empty chair and use a long lens to take pictures unobtrusively. Remember, patience is the key word. Don't just dash in for five minutes and expect to get good pictures; stay for the full period. Follow what the teacher is saying and watch carefully for reactions.

If you intend to photograph your own child in the classroom, tell him beforehand that you want to take some pictures of his class. Don't single him out for exclusive attention; it may annoy and embarrass him. This bit of psychology can pay off in more ways than one: Your child will feel happier about your being there and you can get better pictures of him; and the other children may provide picture material you never dreamed possible.

There are advantages to photographing a child while other childen are present. Besides being relieved of the task of entertaining him, because he now has a playmate, you will also get a glimpse into his nature as he reveals it to friends of his own age.

In order not to disrupt the schoolroom, one has to shoot by available light. These were done with medium long lenses and nearly wide open apertures on Tri-X film.

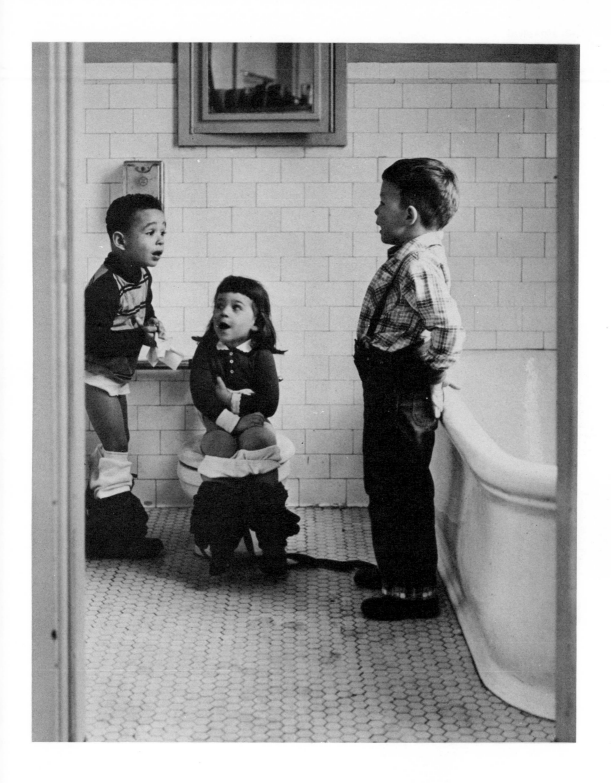

A truly humorous photograph is a rarity, so I especially treasure those that invariably make people smile. This bathroom conference was caught on Tri-X film, 1/125 sec. at f/8.

The Hospital

When you visit a child in the hospital, by all means take your camera along. Hospital rooms are well lit as a rule, and your picture-taking will provide some fun and excitement for the sick child. This is a marvelous place for a Polaroid camera with its fast lenses and instant gratification of your subjects. It is also in the hospital that you probably will take the very first picture of your child. The baby on this page is just five hours old.

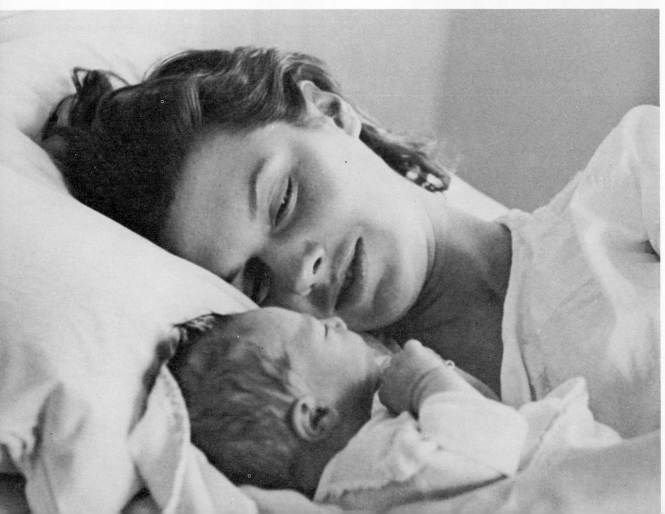

Dancing Class

Most dancing teachers will be glad to let you take photographs, if you promise not to disrupt the regular routine. Your exposure will depend on the amount of light available in the gym or hall and on the type of photograph you want. The dancing class offers a wonderful opportunity to experiment with photographing motion by using relatively slow shutter speeds or to single out one little girl, using your lens wide open. Note how the blurred surroundings add to, rather than detract from, the effectiveness of the figures. I wonder what the little girl was thinking when she made this face at me. I guess we shall never know.

In general, don't pass up a photograph that will record the child's reaction to the camera—to being photographed. You will discover the whole range of emotions—from anger and painful shyness to narcissistic pleasure and excessive vanity. If your approach is correct, children will usually enjoy being photographed because they like the attention.

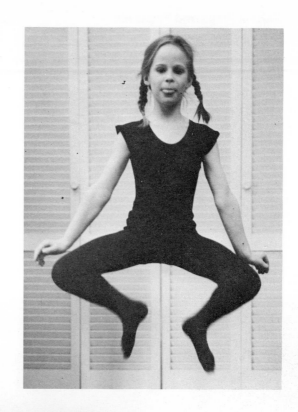

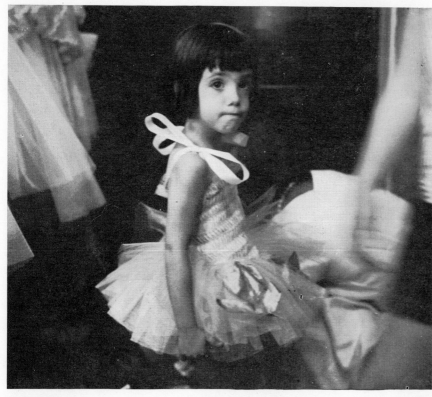

(Above) Chrissy jumping. Tri-X film, 1/250 sec. at f/2.8. (Opposite) Girl dressing for performance. Tri-X film, 1/30 sec. at f/4.

41

School Plays and Pageants

In all the hubbub and excitement of a school performance, you will easily pass unnoticed and thus have excellent opportunities for candid shots. The dressing room will usually be teeming with spirited children and doting parents, and your main trouble will be keeping the way clear between you and your subject.

Once the play or recital starts, you may have trouble finding a suitable spot close enough from which to shoot. Wherever possible, take a meter reading with the stage lights on before curtain time because stage lighting is very deceptive. Generally, I prefer to photograph at a dress rehearsal rather than at the actual performance because I usually have more freedom to move around. For such occasions, a long lens is best and a spot meter is ideal.

Don't neglect the secondary features of a performance: the audience and the children waiting in the wings to go on. All deserve your attention and may provide you with your best photographs. And do not

(Below) The three little girls waiting to go on stage were caught at 1/60 sec. at f/2.8. (Opposite) A member of the audience at a school play was photographed before the house lights were turned off. Tri-X film, 1/30 sec. at f/2. (Below right) The circus performer at dusk; also on Tri-X film.

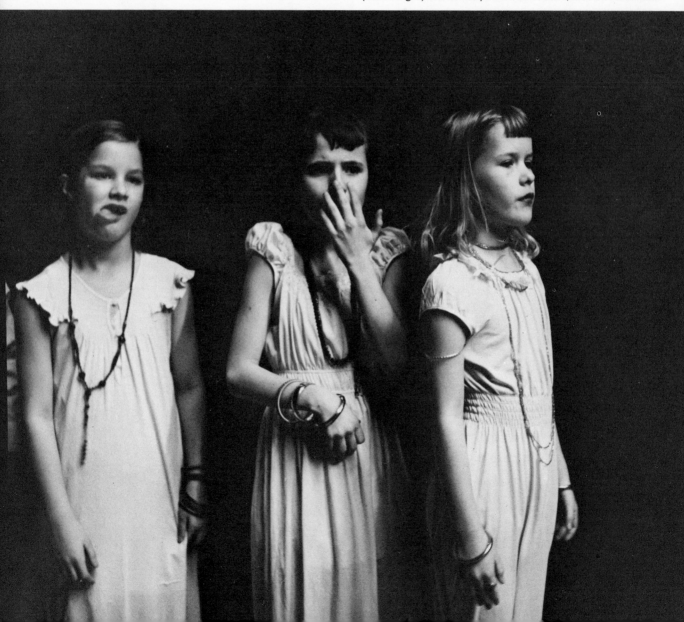

pass up good shots just because you did not have a chance to take a meter reading in that particular spot. Fast decisions and an occasional disregard for a technically unfavorable lighting situation will often produce pleasant surprises, while plodding and meticulous attention to all technical details can produce run-of-the-mill results. Being constantly on the lookout for unplanned and unexpected actions, scenes, expressions, and poses has rewarded me with many of my best pictures; it cannot fail to do the same for you.

Sometimes you will find that an accidental overexposure, resulting in extreme graininess, proves to be the most exciting picture on the whole otherwise correctly exposed roll. By the same token, the boldly lit bare outline of an otherwise underexposed figure may produce a beautifully moody or symbolic effect.

YOU CAN PHOTOGRAPH YOUR CHILD ANYWHERE!

When I started to photograph, it took me a while to believe that one could photograph practically anywhere in black-and-white using fast film. It gave me a tremendous sense of freedom to follow my subjects into supermarkets, department stores, trains, or subways and to come back with more than I had realized at the time I was taking the pictures. Available light photography preserves the atmosphere and background and adds another dimension to children's pictures.

Department store, barbershop, supermarket—they're all happy hunting grounds for your camera. My rule: If you can see to read, you can photograph on Tri-X film. You may have to wait for the peak of the action, but 1/60 sec. at fairly wide apertures will usually do it.

All I carried with me on such excursions was one camera loaded with Kodak Tri-X Pan film, a light meter, and a pouch belt with lots of extra film. Looking nonprofessional had its advantages: No one bothered to stop me or to question what I was doing. Had I gone with three cameras, a gadget bag, and flash equipment, I would have evoked more suspicion and opposition. (The A & P food chain, for example, has a rule that its main office has to handle permissions for picture-taking and so do many other public places.)

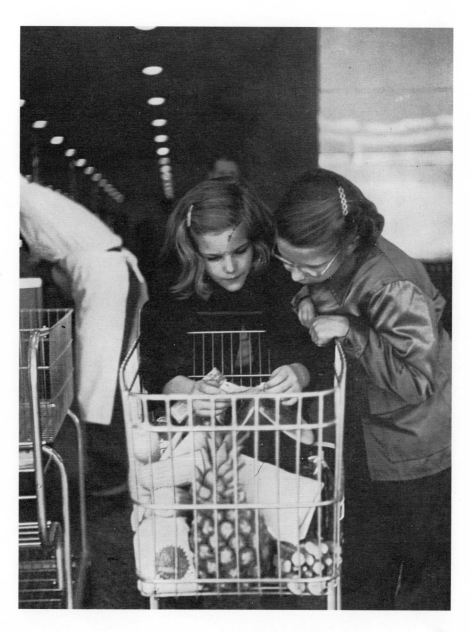

SUPPLEMENTING AVAILABLE LIGHT

So far we have been discussing situations where you can photograph with available light only. In many instances, however, I take along a bagful of lights just in case. When possible, I even take meter readings in advance at my location to be sure that I won't encounter exceptionally dark situations where I would need more than my usual two photofloods and 100 watt-second electronic flash.

Many times the decision of whether or not to use additional light sources will be merely a matter of taste. If you are shooting for publication, however, I would suggest that you stay on the safe side and use some lights. But if you are just shooting for fun and excitement, stick to available light whenever possible.

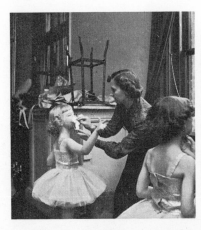

Filling-in doesn't always result in a better photograph. Of these two pictures, the one shot with available light is better by far. It eliminates unsightly background and puts the emphasis where it belongs—on the little girl.

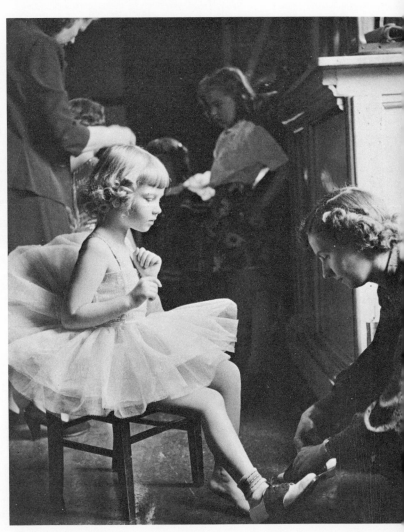

PHOTOFLOODS

One of the simplest and least expensive ways to supplement available light is with photofloods. If you learn to do it skillfully, not even an expert will know whether or not you used lights. Remember, we are *not* talking about using photofloods as the main illumination now but just as a supplement to whatever available light exists. In an average-size room with a light-colored ceiling, set up one or two No. 2 reflector floods. Aim them straight up, about three feet from the ceiling in the part of the room farthest away from the window. Take meter readings to make sure that this bounce light is not more than half as strong as the light coming through the window. After

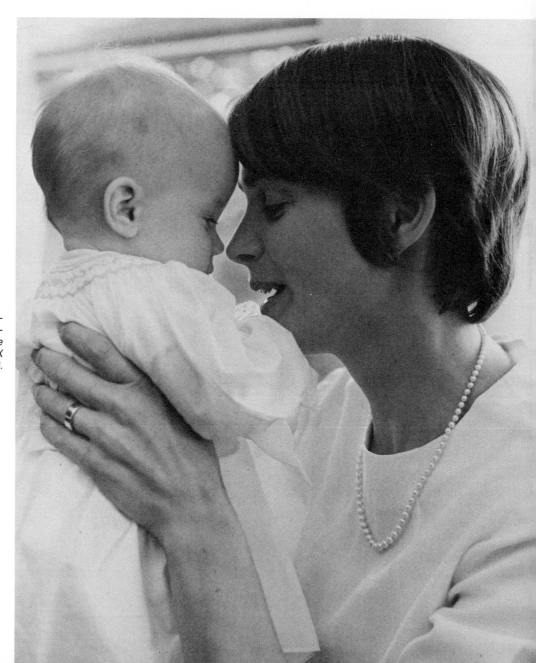

One bounced No. 2 photoflood fills in the daylight coming through the window in the back. Tri-X film, 1/60 sec. at f/5.6.

some practice with the meter, you will be able to create a pleasant balance by evaluating the scene with your eye. After all, one of the biggest advantages of using floods is that you *see* what you will get.

On the other hand, there are drawbacks to using photofloods: You need an outlet; the wires can get in your way, and what is worse, in the path of playing children who may pull the whole contraption down on them. This is extremely dangerous, and you must take every precaution to see that it does not happen. Whenever possible, run the wires under rugs or behind furniture. In summer, the heat generated by photofloods may become uncomfortable, especially if you leave them on continuously as I do so that no one knows when I am actually shooting. In fact, I often set up my photo-

flood ahead of time, and if I have succeeded in keeping it in an inconspicuous place, children will often notice its presence only when I turn it off after I am through taking pictures. Then they may complain that it is too dark all of a sudden.

Yes, luckily eyes can easily adjust to the greater intensity of light that we need for our photography. Keep the lights at least five or six feet away from your subjects, not only because of the danger of bumping into them but also because bounce light will create rings under the eyes if used too directly over the child you are photographing. The height and color of the ceiling will, of course, determine how effective the photoflood will be. Fortunately, most ceilings are white and from nine to ten feet high—the ideal situation for bounce light.

BOUNCE PHOTOFLOODS AS YOUR MAIN LIGHT

There may be occasions when you have to use photofloods as your main light. At such times you will need at least two No. 2 photofloods to provide enough bounce light for shooting around 1/60 sec. at *f*/4 to *f*/8 in an average-size room with a light-colored, nine-foot ceiling, using Kodak Tri-X Pan film rated at about ASA 1000.

Again, you must place the lights so that they will not endanger anyone and still produce a flattering, soft light instead of a harsh overhead effect. Ideally, it should again be impossible to tell whether you took your pictures with bounced photofloods, with existing light, or with a combination of these. If the floor is extremely dark, a white sheet, towel, or even a few sheets of newspaper will help to fill in from below. Be careful not to include the reflectors in the picture.

Bounced floods, with the usual house lights still on, will give a natural-looking effect: Your subject's eyes will not be disturbed; and you won't have to watch for lightspill into your lens as you do with direct floods.

If you decide not to economize on bulbs and current and leave your lights on during the whole shooting, your subject's eyes will get used to the extra illumination quickly. With no popping flashlight to give away the exact moment when you take your pictures, you will be able to work unobserved.

Three photographs with bounced photofloods. In a normal-size room with a light-colored ceiling and walls, I find myself using Tri-X film and a camera setting of 1/60 at f/4 or f/5.6 a great deal of the time.

DIRECT PHOTOFLOODS

Whenever the ceiling is so high and/or dark that bounce light is too weak, you will have to use direct photofloods. On occasion, I also use direct floods to highlight blond hair or just to get a little variety from a preponderance of bounce-light pictures.

Some children's eyes are too sensitive to withstand a light shining directly into them; if you do have to aim your lights directly at them, move the lights as far away as the room and your exposure will permit. If you use standard metal reflectors instead of the reflector bulbs I recommended for compactness, you can diffuse the strong, direct light with a handkerchief or a piece of tissue paper. Remember, though, that these may catch fire if you have your lights on for a long time.

Place the fill-in light farther away than the main light (which is usually to the side

of your subject) and turn it slightly toward the camera for a backlit effect. Be careful not to let light spill into your lens!

You can shoot with direct floods anywhere and get tremendous variation, even with two lights. But direct floods will reduce your chances to shoot really candidly; they will tire your subjects more quickly; and they will demand more setting, resetting, and fussing than bounced floods. Also, don't forget that direct photofloods can become most uncomfortably hot and should be avoided with small babies and during warm weather in general.

When used wisely, direct floods can give your photographs a round, third-dimensional quality no bounce can equal.

(Opposite) Two direct photofloods at about six and eight feet away from the baby. Tri-X film, 1/125 sec. at f/4. In the top photograph, one of the photofloods is aimed straight at my subject's back and is hidden; the other is to the left of the camera. I would only recommend this set-up with older children who can be counted on to avoid hurting themselves on the light behind them. In the lower picture, one direct flood is high on the left, behind the upright piano; the other is slightly to the left of the camera. Both on Tri-X film, 1/125 sec. at f/8.

4

ELECTRONIC FLASH

Electronic flash has created opportunities for taking photographs that would otherwise have been impossible. The clarity of detail and depth of field in a fashion layout; the incredible frozen beauty of a single drop of water; and the suspended flight of an athlete caught in midair are all splendid additions to our knowledge of the world.

But in my opinion, flash has a much smaller place in child photography because children are too easily distracted by the flashing and too interested in the process itself to continue doing what you wanted to catch in the first place. I prefer available light, augmented by photofloods if necessary, especially if I am to follow a child around for some time.

Flash makes my presence known every time I press the shutter release, so I use it only on the following occasions: to catch something unexpected or action that is too fast for other methods; to create a color cover-type shot (there is no surprise element in this type of shot anyway); and when I walk into a room without previous preparation.

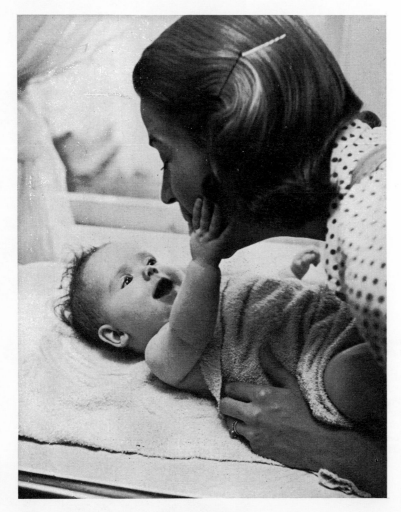

One 100 watt-second electronic flash provides the front lighting in the picture of mother and baby, and a window the backlighting. Tri-X film, f/5.6. On the opposite page, the same flash fills in light coming from a window on the left; but it was farther from my subject than before—about eight feet—so as not to overpower the windowlight. In such a case, a camera that synchronizes with flash at all shutter speeds is a great help; otherwise, you could get ghost images at 1/30 sec.

USING ELECTRONIC FLASH
TO SUPPLEMENT DAYLIGHT

I supplement daylight with electronic flash in only two situations: when I want to fill in strong daylight coming through a door or window; and when the daylight is too weak for a convenient exposure. I made the series of exposures on page 54 by bouncing a 100 watt-second Mighty Light from a nine-foot white ceiling in an effort to determine the best camera settings under such lighting conditions.

Now when we talk of exposure in connection with electronic flash, we usually think of only one factor: the f/stop. Every flash has its own predetermined duration, so what difference does it make whether you set your camera to 1/30 sec. or 1/250 sec.? you might ask. Well, it does indeed make a difference when you want the existing light to register also, and I always strive for this in order to make my pictures look natural.

If you set your shutter at 1/30 sec., you allow more sunlight or room light to register, but you also run more risk of getting "ghost images" with movement. On the other hand, by setting the shutter at 1/500 sec., you eliminate all movement but sacrifice any semblance of available light photography. Obviously, you should compromise, varying the shutter setting from 1/30 sec. to 1/125 sec., depending on the strength of the existing light, the possibility of sudden movement, and the height and reflective quality of the ceiling from which we bounce our light.

With leaf-blade shutters, synchronization is not necessary. With focal-plane shutters, however, electronic flash can only be synchronized at certain shutter speeds, usually a minimum of 1/60 sec. but sometimes 1/125 sec. However, focal-plane shutters will work with flashbulbs at any shutter speed. Check the manufacturer's instructions for the electronic flash synchronization with your particular lens.

Always let your flash unit recycle fully to get the same amount of fill-in. Of course, if you get just the expression or action you are after, then don't wait—shoot! In each of the tests shown on this page, I waited for full recycling.

The same bounced electronic flash was used in all four photographs, but the shutter speeds were varied. Top to bottom: 1/250 sec., 1/125 sec., 1/60 sec., and 1/30 sec. The f/stop was kept constant at f/8. Note the increased role of daylight and the emergence of ghost images as the exposures grow longer.

ELECTRONIC FLASH AS YOUR ONLY SOURCE OF LIGHT

There are situations when you have to use electronic flash as your only light source, and a unit of about 100 watt-seconds should serve the purpose. By bouncing it off a fairly light-colored ceiling of average height, you should get satisfactory results at f/stops like f/5.6 and f/8 with Kodak Tri-X Pan film rated at ASA 1000 and developed normally in Acufine or D-76.

The picture of father and child shows what happens when you bounce electronic flash from the ceiling without providing any reflecting surface below. There was no light to fill in the father's face, and I think my light stand must have been placed too close to my subjects. But interestingly enough, the contrast between the whiteness of the child and her outstretched hand and the darkness of the father's face is not unpleasant and contributes an element of design to the picture. There is nothing like luck, I always say.

But if you don't want faces to be lost in shadow, it is safer to place some reflecting surface near a subject who may lower his face. As I mentioned before, towels, sheets,

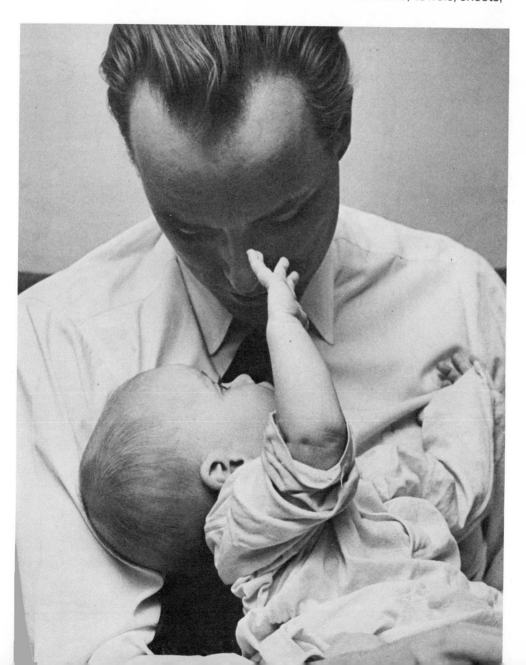

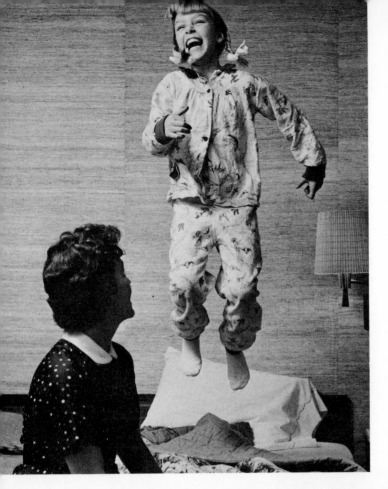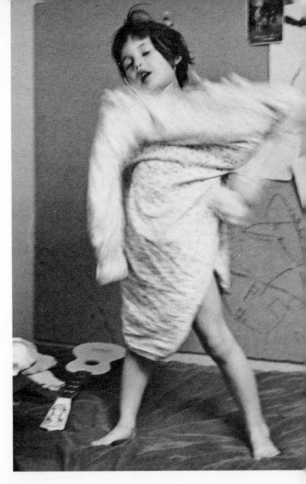

Flash lets you stop action, and blurs make you imagine action. It's a matter of taste and convenience which one you choose. Patty jumping on bed (left), caught with a Mighty Light electronic flash at f/8. Andrea dancing on bed (right), taken with available light, 1/60 sec. at f/4. Both taken with normal lenses on Tri-X film.

and newspapers all make good reflectors.

When photographing in a room where the existing illumination is pretty weak, you will find it easier to focus if you remove lampshades or bounce a No. 1 or No. 2 photoflood. If you are using regular flash, you can shoot at any shutter setting; with electronic units, however, it is not so simple. Some focal-plane cameras synchronize electronic flash only up to 1/60 sec.; at such speeds, this additional light will register. Whether or not you want this is up to you. I find that by shooting at around 1/60 sec., I can usually avoid secondary images (not with bouncing children, of course!) and obtain a pleasant, almost imperceptible

general illumination that softens the picture.

If the situation requires that you walk around a room, shooting candidly and unhampered by wires (as at a birthday party where the existing light is too weak), an electronic flash unit on the camera will do the job, provided you have some mechanical means for bouncing it. A tilting flash bracket is excellent; gooseneck attachments are also available at no great cost. Incidentally, some photographers can bounce their electronic flash unit with one hand and hold the camera with the other.

If your unit requires a battery pack, hang it on your shoulder or better yet, clip it to

your belt; that way, you are really independent of wires and ready to move around. If you attach your flash unit to a light stand, you will have even less to carry around. I always lengthen my synch cord with a 10- or 20-foot extension cord so I can move around freely with only the camera in my hand.

Be sure to take into account that bathrooms are small and that there are usually many reflecting surfaces; so stop down your lens properly. These pictures were taken with one bounced 100 watt-second flash, Tri-X film, at f/11.

5

PORTRAITS

Whenever I undertake to photograph a child, parents usually ask me to take a "portrait" as well as the type of candid pictures they know from my magazine work. Whether this portrait will be the result of a carefully lit close-up or the fruit of a lucky moment when the child looks up from his play, one can never tell. So I try both approaches.

I was not always so flexible. I used to think that only the kind of picture you see at the bottom of this page was a *real* portrait. I was much too anxious to "do it right"—plain background, even lighting, perfect sharpness, and a big smile. The results were forced and artificial. For the larger picture at left, all I used was a No. 2 photoflood to fill in the windowlight. I think you'll agree that it is a nicer portrait than the example of my earlier effort which, by the way, was made when I did my work in a studio.

Never again! Nowadays, if for some reason I cannot go to the child's home, I invite the child to my home, where we can play records, raid the icebox, or read books without the distraction of a studio's shining lights and the chilling effect of its bare, impersonal walls.

Portraits can, of course, be taken by available light, floods, electronic flash, or any combination of these. With available light and floods, you will more or less get what you see at the moment of exposure; when using electronic flash or regular flash, you will have to do a bit of guesswork.

I don't wish to be repetitious, but I would like to remind you of the importance of the background. There is only one rule covering the background you should include in a portrait: It should be subdued and different in tone from the subject's face. This is a constant problem and one which occasionally gives me difficulty. For example, the portrait of Debbie on page 60, taken with bounced electronic flash, suffers from having a background that is nearly the same color as the little girl's face.

Every manual tells you to "Give the child something to do while you pose him or her." This sounds simple, but a good deal of patience and consideration is needed for good results. Children do not like to do anything under pressure. As a matter of fact, they often like to do the opposite of what you suggest.

The question, "Can you see yourself in the lens?" will often produce a curious, attentive look on the face of an otherwise stiff child. And if your subject simply will not stay put long enough for focusing, wait until he gets hungry; he will have to sit down to a meal eventually. In such a case, I carefully check in advance to be sure that the background behind the child's usual seat

Artificiality is the best word to describe this small picture, both in technique and mood. The picture on the opposite page, on the other hand, preserves natural lighting and lets us get to know Sandy as she really is. The two photographs are 16 years and many thousand exposures apart in my career.

 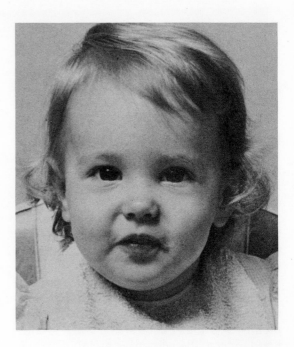

(Above) *An example of extracting a portrait from an everyday scene by cropping in the enlarger. If you have a camera that doesn't let you get close enough to fill the frame with the face alone, this may be a good solution. (Below) Not every child is at her or his most attractive when smiling, especially at the "new tooth" age. In the case of the beautiful but shy Lisa, the pensive portrait is both more truthful of her character and a beautiful portrait.*

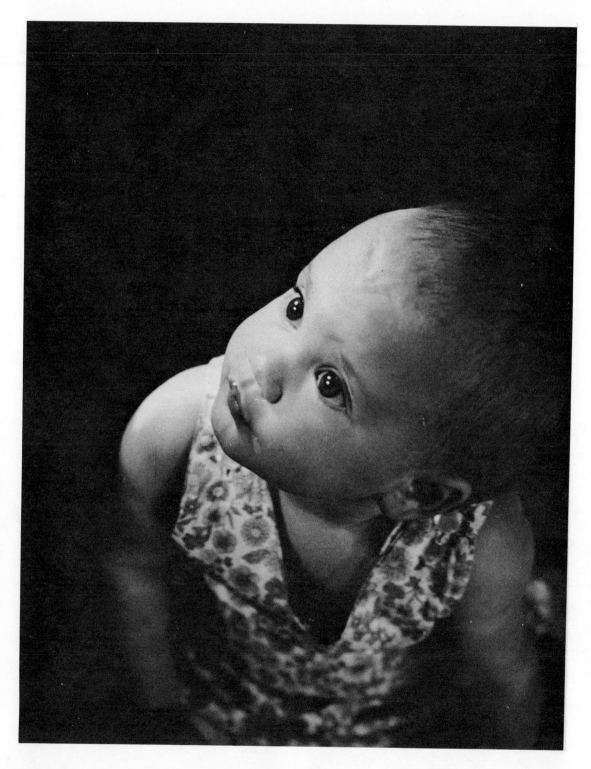

An illustration of what happens when one uses the camera at eye level, without getting down to the child's level. Once in a while it produces a dramatic photograph, but in general, it is a practice to avoid.

will be suitable; if it isn't, I remove distracting objects or move the table slightly. Moving the child rarely works, since most children are slaves to routine; changes disturb and upset them.

When trying for a more or less formal portrait, with the child "looking straight at you," your ability to get along with your subject will be put to a test. You will have one powerful ally—the child's vanity and pleasure in being the center of the stage.

Some say that a photograph in which the subject is looking straight at the camera is not a candid shot. I disagree. If the child is very conscious of the *camera*, you will get a candid picture of what effect the camera, the picture-taking, had on the child; and if the child reacts to *you*, not as a photographer but as a person, the photograph will be a candid revelation of the emotion you evoked in the child.

As long as you let children be themselves, as long as you don't make them conform to some preconceived notion you have, your pictures will be candid. Of course, it may be difficult to decide which of the pictures you took reveals the true nature of the child. Probably they all do because children, like grown-ups, harbor many conflicting emotions and characteristics.

Three frames from a good portrait session. Katie and I had a lively conversation while she was perched atop a stepstool in their garden. (I have noticed that children will sit on anything unusual, like a stool or ladder, much more happily than in a chair; moreover, the photographer will not have to contend with the back of the chair ruining the background.) I had her facing away from the hazy sun, of course. Minolta with 100mm lens, Plus-X film, 1/250 sec. at f/4.

6

COLOR

Color photography is full of contradictions. Among them:

1. Color is basically an easier medium than black-and-white because you get what you see. With black-and-white photography, you have to work with the contrast of light and dark, which translates colors into different shades of gray. *But* it is technically harder to re-produce this simplicity in color photography because a very special effort is needed to lift a color picture above the level of mediocrity.

2. Color photography is realistic. *But* color film reacts strongly to changes in the quality of light. For instance, if the light isn't truly white, snow will appear blue in a color picture. People generally reject such results as being unrealistic when, in fact, it is a true rendition.

3. Colors can "make" a picture, showing the lovely skin, hair, and eyes of children. *But* a discordant color combination can ruin many a picture.

Because of these contradictions, color photography demands more taste, selectivity, and attention to detail and background color.

One of the most important differences between color film and black-and-white film is in the contrast range. With black-and-white film, it is possible to render contrasts as high as 1:30; the contrast range of color film is much more limited, and 1:5 is about the highest that a person's eyes will accept. Let's take the flesh color of a face, half lit by sunshine and half in deep shade. In black-and-white, the result can be an interesting photograph; but in color, one side of the face will be a light yellow or pink and the other an almost deep brown.

Because of this lack of latitude in color photography, it is also much harder to avoid error in exposure. Unless you are among the few who do their own color printing, there is no possibility of correcting your mistakes in the printing process, as you can with black-and-white.

The problem of too much contrast can be avoided if you work in even, soft light—under an overcast sky outdoors or bounced flash indoors. If you want to take color pictures of people on a bright, sunny day, some kind of fill-in is nearly always desirable. Caution: If the fill-in is provided by a sunlit wall that happens to be blue, for instance, it would be fine for black-and-white but not for color, as the photograph would have a bluish hue. A white wall is fine for color, and so is a white sheet or blanket. I often put a sheet down in front of me, just out of camera range, when photographing on a lawn; it minimizes the green reflections.

You can also use electronic flash and blue flashcubes. The distance from which you fill in, and your decision to bounce your fill-in light or use it directly will determine whether your pictures will appear natural or look overbalanced and artificial.

Once in a while I like to use regular tungsten light and photofloods to fill in window-light indoors; on daylight film, tungsten light gives a golden glow to the photograph, which can be very beautiful. On the other hand, if you let daylight register while shooting on tungsten-type film, you'll get an eerie blue cast wherever daylight touches the picture.

I listed my favorite color films on page 16, so I'll just add one important accessory here, namely, a Kodak Skylight (1A) filter. I use it on most of my color pictures to remove any bluish cast lurking in the light, especially from an overcast sky. There is no need to compensate for it in your exposure, and if you forget to remove it, it won't hurt your next roll of black-and-white either.

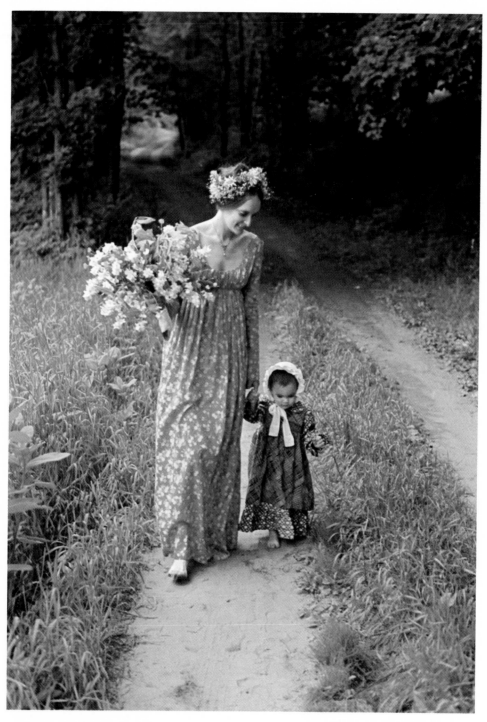

This mother and child were walking through the woods in Vermont, on their way to an outdoor wedding. By practically walking backward all the way, I finally succeeded in catching them by themselves, without all the others walking with us. Kodak High Speed Ektachrome (Daylight) film rated at ASA 200, 1/125 sec. at f/4.

(Left) The overcast day's soft but cold light warmed with skylight filter. Kodachrome 64 film, 1/250 sec. at f/4. (Right) Daylight from two windows created a perfect light for this portrait of Hilary. Kodak Ektachrome-X film, 1/60 sec. at f/4. (Below) A carefully posed mother and child in the late afternoon's golden light. The sidelight emphasizes the beauty of the surroundings. Kodak Ektachrome-X film, 1/125 sec. at f/5.6.

(Above) I like to photograph children when they are involved with someone else and I can shoot unobserved. For this, a 100mm lens is ideal. Minolta SR-T 102, Kodak Ektachrome-X, 1/125 sec. at f/4. (Below) I walked into the kitchen just as Barney the dog decided to share the breakfast of Billy the child. Electronic flash filling in windowlight, 1/60 sec. at f/5.6.

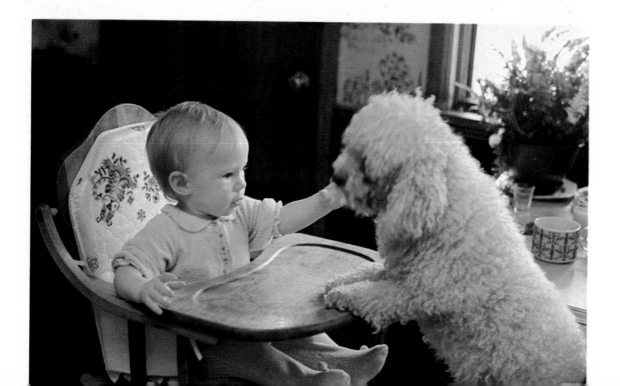

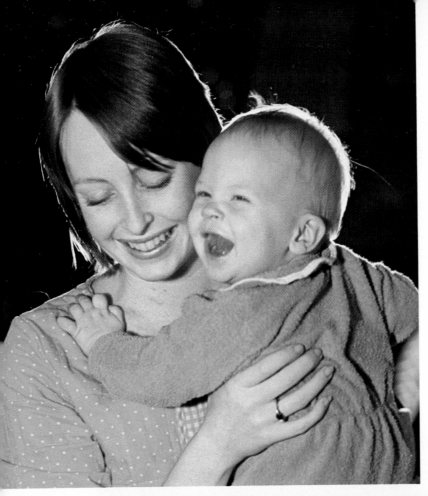

(Left) There was ample room behind my subjects to set up one of my photofloods aimed straight at their backs, creating a halo; I was careful not to let the backlight show. The second light was near the camera. This is a lovely light, but I'd never use it if the child was not being held; there is just too much chance of an accident with the lights. Kodak High Speed Ektachrome (Tungsten), 1/125 sec. at f/5.6. (Below) My favorite light—open shade—and a picture combining my two favorite subjects— children and flowers. Kodak Ektachrome-X pushed ½ stop, 1/125 sec. at f/4.

WORKING WITH NEGATIVE COLOR FILM

Because you can make both color and black-and-white prints from your color negatives and so have the best of both worlds, negative color film (Kodacolor, Vericolor, and so forth) can be an exciting discovery. Negative color film gives you great freedom and will also help you develop that sixth sense which will help you decide whether to use color or black-and-white for a certain photograph.

I cannot brag that I always know which will be better, so I often duplicate shots; but if I had only one camera with me, here is what my approach would be:

I would first look at the light: Is it soft or contrasty? (Remember that color film tolerates less contrast than black-and-white!) Then I'd look at the colors: Are they working together? Are they important to the photograph (gorgeous blond hair, for instance)? And how will the color of sky and surroundings affect the important parts of the picture? (That, of course, is the hardest to guess.)

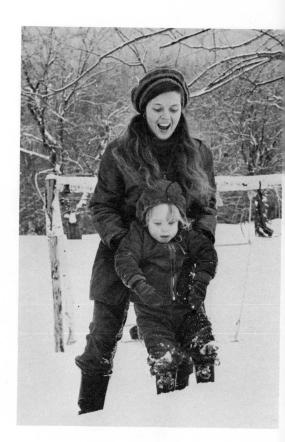

(Left) Maya was holding her pet rabbit in her arms. The color proof showed mostly a bright red rabbit, distracting from her lovely face and nice expression. Then I made a black-and-white print; now the red rabbit showed up as darkest gray, and suddenly the face, being the lightest area, became the focus of interest—as it should be. (Right) In the picture of the mother and child playing in the snow, the trouble with the color rendition was that even with proper exposure, for some mysterious reason the snow came out yellow rather than white. So again a black-and-white print saved the day.

65

SOME DO'S AND DON'TS ABOUT CHILDREN'S PORTRAITS

A pretty profile

Blond hair

Along the way, I've learned some do's and don'ts about making a portrait of a child:

1. If your subject has *freckles*, use an orange filter to minimize them. But remember to increase the exposure when you do. Inci-

dentally, the orange filter will affect anything else in the picture that is orange-red.

2. If you photograph a child whose best feature is *beautiful eyes*, shoot slightly down on the child so that the eyes dominate the picture.

A chubby face

Beautiful eyes

3. A *pretty nose* can be emphasized in profile shots.

4. A *chubby face* should not be photographed head-on but in a three-quarter view. Use strong sidelighting so that half of the face is well illuminated and the other half is in relative shadow. Strong window-light coming from the side or a direct photoflood aimed at one side of the face will produce this effect.

5. *Blond hair* will look prettiest when backlit by sun or photoflood.

It is obvious that you will judge a child's portrait according to whether or not the subject is your own child. If we are talking about your child, many considerations besides artistic ones will decide whether you like a picture. If your daughter's hair seems lighter or darker than it really is, if her dimples don't show, or if stray hairs are highlighted, it may be a photograph that delights everyone except you, the parent.

I must have captured something that Kate's parents liked, because they overlooked the intrusion of the tree and preferred this shot over many others that I took.

7

CLOTHING

When you photograph for your own pleasure, without having to please anyone but yourself, the question of suitable clothing and hairdo does not arise. Rumpled, muddy clothes and disheveled hair are just as much a part of the true picture of a child as are dainty party dresses and perfectly groomed hair. Only when you are trying to please parents or clients do you need to concern yourself with hair and clothing.

Whenever I am asked what clothes would be suitable for a child who is to be photographed, I try to dodge the question by saying, "Oh, whatever he usually wears—something he likes to wear." This gives me a chance to see the child before he has to go through the ordeal of dressing up in his Sunday best, whether or not he feels like it. And if the shirt is too "loud" or the dress too fussy, I can always suggest changes after a while, when I can judge whether the child will go along with the idea willingly. Children can be touchingly grateful for being asked about their choice in this matter; it's also quite interesting to see how they want to be portrayed. Many will consider it special fun to get all dressed up for some pictures; others will insist on being photographed in an old felt hat.

I have only one request when it comes to dress: *no new clothes!* Parents usually buy clothes big enough to keep up with a child's growth, and the child will look lost in them at first. Also, older clothes are much more comfortable as a rule.

Large areas of black or white in clothing present special problems. Getting detail in black clothes is practically impossible with simple lighting set-ups; even more disturbing in a print is a stiff white shirt rendered without detail. Sometimes, one can "print in" the detail during enlarging, but it is far better to cover most of these areas with a pastel sweater when one takes the pictures.

As a photographer, I love this picture, although Charlie's face is dirty and his shirt much too big. But I can see that his grandmother would probably prefer a cleaner photograph of him, even at the risk of losing this wonderful expression.

Ideal clothing for a pretty picture of Maya: a small-patterned pastel print. I had to watch the background to make sure it would appear a different tone of gray in the final black-and-white print. Plus-X film rated at ASA 200, 1/125 sec. at f/5.6.

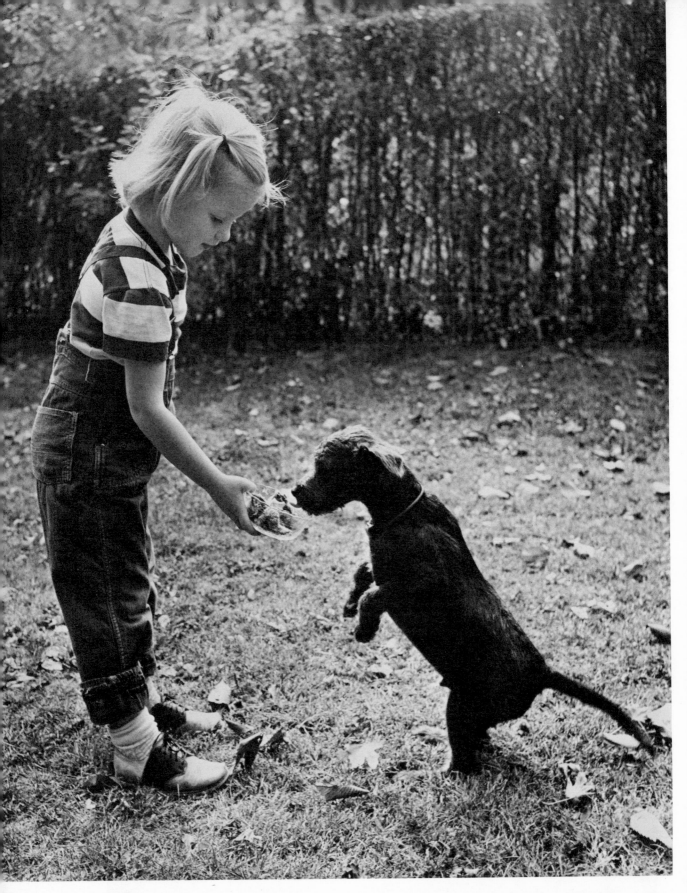

8

CHILDREN AND ANIMALS

There's a pretty cynical saying in some areas of the picture market that "You can't miss with a picture of a baby and a dog." I tend to agree, but not because everyone is touched by this combination. I like to photograph children with animals because they love each other and because you rarely get a "posed" picture when dealing with two beings as emotional and volatile as a child and an animal. Rarely is the candid approach more effective than in this combination of child and animal.

It takes patience and luck—usually both. One moment you will feel that the child is hiding the animal or vice versa; the next moment you'll be afraid they are too far apart for good composition, or moving so fast that you don't have time to focus. And if you don't want to end up wishing you had never suggested feeding the dog or playing with the cat while you try to take pictures, you'll have to be unusually quick and alert.

Anticipating all these difficulties, you should try to create the easiest possible technical set-up. Be sure there is sufficient light to stop down at least to f/5.6, preferably f/8, and shoot at fast shutter speeds like 1/125 sec. or 1/200 sec. If you ever use flash, this is a good time for it. In any case, the light should be even and should cover enough area to permit freedom of movement for your two subjects.

When choosing a background, don't forget to consider the color of the animal. Dark or black animals should be photographed against a light-colored background and vice versa.

As I wrote down this obvious piece of advice, a beautiful photograph I saw recently appeared before my eyes to contradict ev-

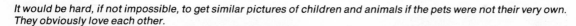
It would be hard, if not impossible, to get similar pictures of children and animals if the pets were not their very own. They obviously love each other.

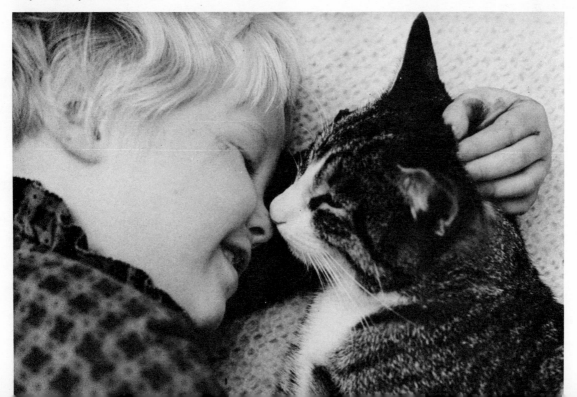

erything I just said—a picture of a black cat and a black child taken against a dark background and nothing but two pairs of eyes gleaming white and important. We also know how beautiful a white cat and a very fair-haired child can look against a spanking white background. It's true that these are the exceptions to the rule and that you must be quite experienced to bring them off, but even if you are a beginner, don't be afraid to break the rules. Just be ready to learn from your mistakes.

Besides taking candid shots of children and animals together, as I did in the preceding pictures, you can also ask the child to pose with his favorite animal. You will usually find that even the shyest child will be amenable if you pretend to be concentrating chiefly on the pet.

If the child is holding a small animal in her arms, shoot from a low angle so you can see her face as she looks down at it. Normal lens, Plus-X film, 1/125 sec. at f/8.

72

9

GROUP PHOTOGRAPHS

Most people think that taking a good photograph of four subjects is four times as difficult as getting a good shot of one of them alone. This doesn't have to be so if your approach is relaxed and easygoing, because the people in the group have each other to talk to and enjoy and consequently won't be stiff or embarrassed. This is particularly true of grown-ups playing with children or of an older child holding a baby; their delight is so real that there simply isn't any time to be self-conscious.

The very young child cannot be expected to play with another young child for any length of time. If you want to photograph them together, do it quickly. Children around three years of age are just learning to play with each other; they are likely to erupt in tiffs, quarrels, and actual physical violence. Until it's time to intervene for safety's sake, the children will have completely forgotten your presence. Just as with children and animals, you must think fast, focus fast, and use fast enough speeds to catch all the action; small lens openings will keep most of the picture sharp.

Among the situations in which you can photograph groups of children candidly are concerts, puppet shows, ball games, or parties. Using a minimum of equipment will greatly increase your chances for preserving the natural mood and atmosphere.

Puppet show at the Fox Hollow folk festival. Minolta SR-T 102 with 85mm lens, Plus-X film, 1/250 sec. at f/5.6.

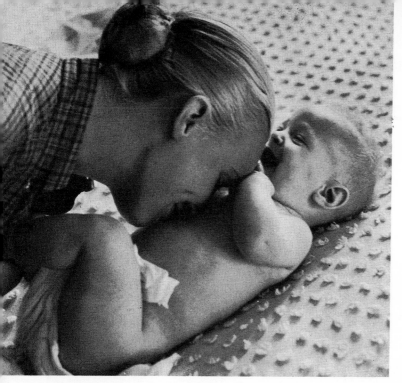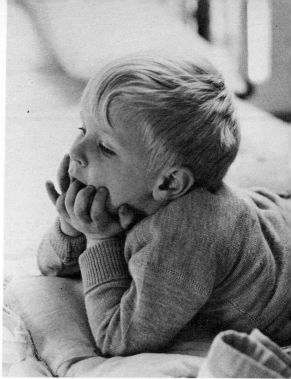

Suppose you wish to take pictures of a mother playing with her new baby. If there are other children in the family, some photographers may be tempted to ask them to stay in another room; this way the photographers can concentrate on their subjects without distracting talk and action. But if you do this, the mother will be nervous, wondering what her children are up to in the other room, and you will lose wonderful opportunities for candid shooting.

For example, in the scene above, Howard assumed a charming pose while enjoying the sight of his mother playing with the baby. It would have been a pity if I had been so absorbed in mother and child as not to notice him. This is what I meant earlier when I said that you *deserve* your luck. If you are constantly on the lookout for every interesting thing that may happen around you, you can be ready when luck throws something your way.

Technically speaking, this means that the whole area where you photograph should be lit evenly so that you can turn in any direction without having to reset your camera. Use whatever daylight or room illumination exists and boost it where necessary with bounced photofloods or electronic flash. If you attach your electronic flash unit to a light stand, remember to use a long synch cord so that you can move around freely.

To catch a subject completely unawares, take up a position approximately equidistant from two children. Focus on the one you do not intend to photograph. When you see that the other one, your real subject, is doing something interesting, turn toward the child and snap. You can be sure he will never realize that his picture has just been taken. If you are skilled at guessing distances, you can, from time to time, preset your camera, but I prefer the first method.

(Opposite) Spontaneous family group caught with one No. 2 photoflood boosting existing light. Minolta with 35mm wide-angle lens, Tri-X film, 1/60 sec. at f/5.6.

THE POSED GROUP PHOTOGRAPH

But what of the more difficult task of *creating* a mood instead of simply *preserving* an existing one? This, too, can be learned. You must be patient and wait for the moment when a whole family group (like the one on this page) will be ready for the "dreaded moment." Make a few tactful but firm suggestions: for instance, suggest that the children change into suitable clothing; or persuade the smallest child to abandon his cowboy hat and gun for the family portrait. This is no moment to be reticent. And while your subjects get ready, find a suitable background, take a meter reading, set up lights if you need them, load your camera, and set the shutter speed and f/stop.

Before the children get too tense or bored from standing around, ask everyone to sit. Tell them to sit close together—as close as possible. Be sure that legs do not stick out in front nor wisps of hair in the back. When everything is in order, you can start your psychological warfare. Begin with the member who seems least happy. When he has been persuaded that this is fun, a few compliments for the whole group may come in handy—one can usually find something nice to say.

I always encourage my subjects to talk as much as they like. Since I can handle my equipment practically without thinking about it, I am able to carry on a lively conversation or to sing funny songs if everything else fails.

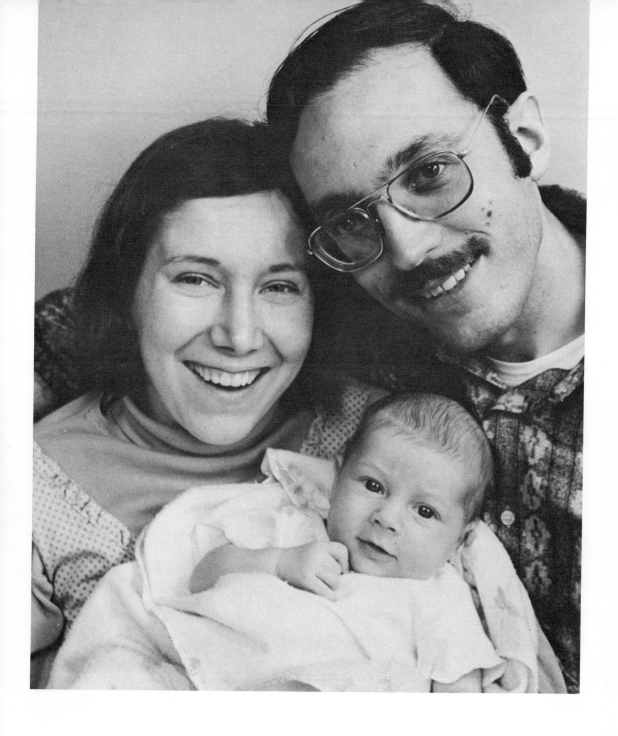

(Opposite) This family picture, which was used as a Christmas card, was posed in the summertime. Wreaths were included, and every member of the group wore something that was red. (Above) It is amazing how close together people should be if you don't want them to appear miles apart in the photograph! Here is a close threesome, carefully posed. I usually tell my subjects that they should try to feel, rather than try to see, each other in such a pose. Photofloods, Minolta with 55mm lens, Tri-X film, 1/60 sec. at f/8.

I thought I'd pose these six lively children on a bench, so I asked them to move it away from some trees into the middle of the field. I quickly grabbed my camera when I noticed what fun they were having while carrying the bench. I won't say that the action picture replaces the formal group portrait, but visually it is more exciting. A hazy day, normal lens, Plus-X film, 1/250 sec. at f/5.6.

78

SPECIAL OCCASIONS

On occasions such as Christmas or birthdays, your problem will be to record them without interfering with the festivities in any way. Otherwise, you will be like the tourist who cannot enjoy his trip because he is too busy photographing it in every detail. He also spoils the fun for everyone else.

If the existing light isn't sufficient for shooting, replace regular bulbs with photofloods in lighting fixtures that can be aimed at the ceiling or clamp a few light sockets with photofloods attached in various locations around the room *before* the festivities start. Leave these lights on all the time so that everyone's eyes can get used to them. Your whole behavior should convey the impression that your photography is secondary to the celebration of Christmas or the child's birthday.

If you shoot quietly and unobtrusively for a while, letting the children enjoy themselves, usually they will gladly stop for a few

Whether your children enjoy their new toys under the Christmas tree or start to fight over them, then and there, it is worthwhile to have your camera handy. Bounced photofloods, Tri-X film, 1/125 sec. at f/4.

moments for a posed group shot under the tree or for the "birthday picture" that is taken in the same spot every year to show how much the child has grown.

At graduations, confirmations, bar mitzvahs, or any similar occasions, the same rules apply: Don't let your picture-taking spoil the festivities. Handling your equipment unobtrusively and quietly will also result in better pictures.

The preparation for holidays is half the fun. As I was shooting color at the same time, I used two direct floods here to catch Elizabeth hanging her Christmas stockings. Tri-X film, 1/125 sec. at f/4.

It took only a few questions, before the graduation ceremony started, to make sure that I would be at the right places to take pictures. Needless to say, on such occasions I never sit down, but discreetly stand in the back, free to move around quietly on my rubber soles. Plus-X film, 1/250 sec. at f/5.6.

(Right) Not everyone is happy at a birthday party, but a picture of a shy child can be charming too. (Below) The lively scene of Marina painting some Easter eggs. Two photofloods, normal lens, Tri-X film, 1/125 sec. at f/5.6.

The Halloween pictures on these two pages were all taken on Tri-X film, as children don't go out trick-or-treating before dusk. I came upon the little ghosts and witches, shown on the opposite page, on a Maryland playground; I only had time to shoot two exposures before they vanished.

11

SEQUENCES

Sequences are a still photographer's movies. They consist of from four to eight pictures showing the buildup and climax of a little event in a child's life. Sequences will enliven your collection of photographs and will be valuable training for shooting fast, precisely, and at crucial moments. Once you assume that every single situation may be the potential start of a sequence, you will find yourself shooting more of them.

It takes a certain sixth sense to anticipate a child's next move. If you are a parent, you'll know what I mean; but even if you are not, you'll catch on pretty fast. One look at the guilty face of a two-year-old approaching the big slide on a playground should alert you to a situation that will be worth watching and photographing. Or suppose you see a little girl blowing up a balloon and you realize she will make a pretty picture. If you catch her while the balloon continues to grow, and if you notice that her sister is planning to puncture the balloon just as soon as it is fully blown, you can shoot a really dramatic sequence.

Do not despair if you miss an intermediate step in the sequence, for instance, the moment the little girl started to blow up her balloon. After her tears have dried, you can console her with a similar balloon (let's hope there's one handy) and photograph her in the pose missing from your sequence. But do this right away; you will rarely succeed days after the original event. Weather, dress, toys—everything is troublesome to duplicate.

(Below) Ideal weather for doing a sequence: slightly overcast. This eliminates dark shadows and lets you shoot from all directions. Ilford FP4 film rated at ASA 200, 1/125 sec. at f/8. (Opposite) Nearly every play activity of your child lends itself to a sequence. This one, of Glenn building a tower, was shot with available light on Tri-X film, 1/125 sec. at f/2.8.

SOME SIMPLE RULES FOR SHOOTING SEQUENCES

For picture sequences, your technique must be even smoother than for single shots. Here are some helpful hints:

1. Use equipment with which you are very familiar.

2. Use available light or supplement it in advance of the shooting. Be sure the lighted area is large enough to follow your subject around if necessary and to shoot continuously.

3. Treat each new picture as the possible start of a sequence.

4. Don't force your ideas on children in a high-handed manner; be gentle in your approach. Even if you are inspiring a sequence, don't make the child aware of it.

5. Be fast, be patient, and be imaginative.

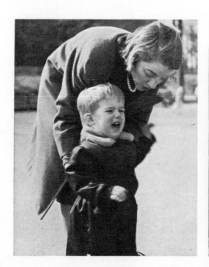
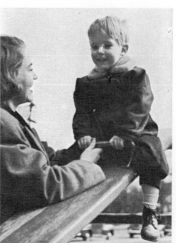

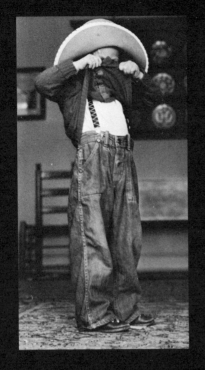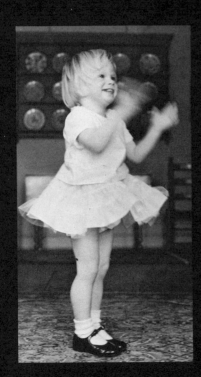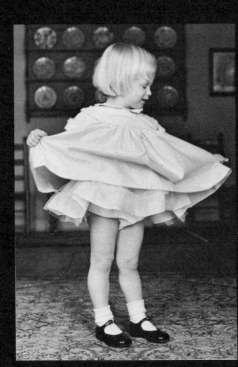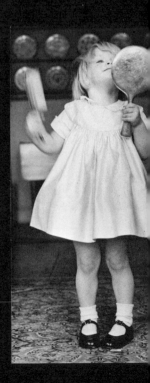

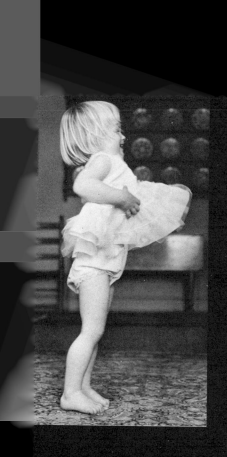

To see how far one can go in planning a sequence without impairing the candid feeling, look at the one of Chrissy and her new dress. I planned the action after I realized that Chrissy, who usually runs around looking like a little cowboy, adores frilly dresses. To make her fairness and pink dress stand out, I chose to shoot her against a dark background. I achieved this by photographing with my back to a big window, using available light and letting the background go dark as it always will if no supplementary light is used. It suited me fine that even though I rated the Kodak Tri-X Pan film at ASA 1200, I could not shoot faster than 1/60 sec. at f/4; I felt that the resulting blurs would emphasize Chrissy's excitement. After starting to photograph her from the back in the nude, I suddenly had the idea of adding to the fun by letting her make a full turn while getting dressed. The rest was easy and did not need more direction than a reminder to Chrissy that she must stand exactly the way her mother placed her after a few spins each time. It was all a game to her—with new shoes to delight her, a tremendous petticoat to explore, and a beautiful new dress to wear. The first and last pictures of the sequence were entirely unplanned and un-posed. I was very careful to carry out my original idea in the enlarging process. I kept the figure of the little girl exactly the same size. Mounting the nine photographs on a black background again emphasized the fair-ness of the little girl and the rhythm of the action.

RECORDING YOUR CHILD'S GROWTH IN PHOTOGRAPHS

Keeping a step-by-step book of your child is not a new idea. As a matter of fact, many parents start one with their first child. They carefully fill page after page during the first few months, but they may overlook such important occasions as the sleepless night they had when the child's first tooth arrived. These parents rarely realize that the album would be much more interesting *if* it were a little better arranged with fewer and better chosen pictures enlarged to different sizes.

After the first few months, the baby learns more and more new things each day. Unfortunately, the family photographer's enthusiasm often wanes around this time.

Why?

Because the child isn't as stationary as he used to be, and photographers who have not learned to use available light may become discouraged by the problems of following the child around. After all, they say, everyone knows by this time what the child looks like, and he isn't changing so fast anymore, anyhow. Pretty weak excuses for being lazy and unimaginative, aren't they?

Ideally, both parents should know how to use a camera so that fewer interesting moments in the child's life will pass unrecorded than if only Father takes pictures. For one thing, Father's picture-taking will probably be limited to weekends.

The picture possibilities are unlimited with a constantly developing child who discovers something new each day, who is surrounded by loving adults, and who responds to one of the persons he knows best —you, the photographer.

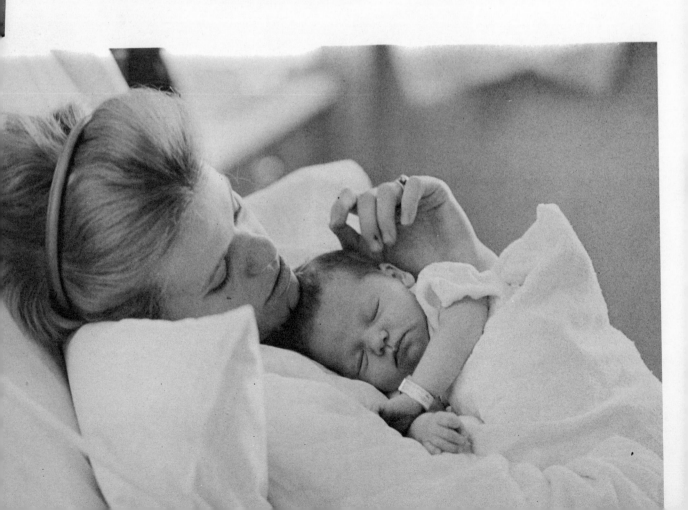

I photographed Melissa, whose picture history you see in this chapter, on the same day of each month, from the time she was three days old until her first birthday. I still take pictures of her often, and I hope that some day she will be interested to see herself grow up in my photographs.

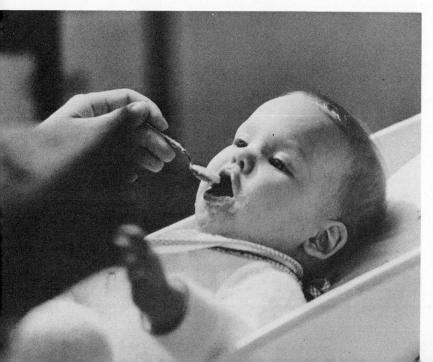

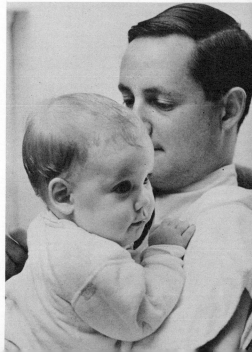

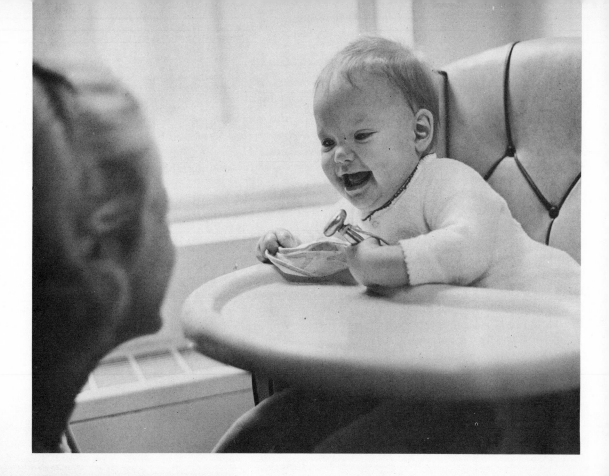

Children who have been photographed regularly since the day they were born—without fuss, hot lights, and restricting demands on their comings and goings—will continue to be the most wonderful subjects. They either ignore the camera, or consider it all a lot of fun, or treat it as part and parcel of everyday life. Naturally, their attitude toward photography will change as they grow from cooing babies into little boys and girls who are fascinated with everything mechanical, like a camera. But that certainly is not reason enough to stop taking pictures of your children after their first year or after a new baby replaces them as the number-one picture subject.

To be sure, they give you more trouble after they start to walk, and they can lead you a merry chase or upset your equipment; but just when you are ready to give up, they will sit down and assume poses and expressions that will delight you and make you glad you outlasted the little monsters.

If you have any of the standard child-development books around the house, such as Dr. Spock's, you will find that you can lift many ideas from them for the photographic record of your child's progress. But all this won't help if you are not ready for immediate shooting when your child next does something new or especially appealing.

Being ready to shoot means that your camera is easily accessible—possibly even with the sunshade attached—and that your film, light meter, and some simple, supplementary light source are at hand, not buried deep in the coat closet. Make it easy for

yourself to keep your resolution about not missing any good shots from now on; if it takes hours to get ready, you're not going to have much of a development album.

You'll do well to mount your photographs so that they will take a lot of wear and tear. You'll want these albums to last forever, and you should let the children look at themselves often. They nearly all love to do this, and they show great pride in all these pictures of themselves, almost as if they wanted to say, "Look! This is all me. I must be a pretty wonderful and important person if my daddy and mommy take all these pictures of me!" And isn't it wonderful that your hobby can make your children feel so proud and happy?

If it's not your child whose development you have started to record, try to continue it anyway. If you do it for your own pleasure, you may find one day that you can sell a careful growth series to any number of publications dealing with child development. If, on the other hand, parents are paying you to photograph their child, you will be doing them an invaluable service they will appreciate later if you can persuade them to have the child photographed regularly, say every three months during the first year and every six months thereafter.

13

CONCLUSION

The pictures you have seen in this book were chosen for two reasons: partly to show you some of my favorite pictures and partly to illustrate points covered in the text (some of the latter are *not* my best pictures!).

Is there anything I could tell you about how and when I took my best pictures? I am afraid not. Sometimes I don't even discover that I have something special until I look at my contact prints; at other times I get all excited while shooting and my excitement doesn't show in the final result. Sometimes I photograph very carefully and the pictures are just so-so; at other times I goof and find that I can be glad I did.

So don't be afraid to experiment. Sometimes, in the heat of action, you may not do everything according to the book; after shooting a picture, you may suddenly notice that your shutter was set at 1/8 sec. instead of 1/125 sec., that your lens was wide open instead of at *f*/4, or that your synch cord was not connected.

Don't be upset. The 1/8 sec. may result in a poetic blur; the overexposure may give you a beautiful high-key effect; and the lack of fill-in may produce dramatic dark shadows.

And if not, you can always try again.

I have tried to share with you what I have learned in the years I have been photographing children for my own pleasure, for parents, for magazines, and for advertisements. If you feel that you still don't know the "secret of my success," that's because most professionals don't have secrets; they are people who have found a vocation that suits their talent, people who just love to do what they are doing, even though on occasion they find it an exhausting and taxing job. And they keep working at it.

I have found photographing children fascinating and challenging—a means of understanding them better and well worth the effort it requires.

I hope you do too.